THE BIG BAD WORLD OF CONCEPT ART

FOR VIDEO GAMES

HOW TO START YOUR CAREER AS A CONCEPT ARTIST

BY *Eliott Lilly*

designstudio|PRESS

Graphic designers:
Eliott Lilly (www.eliottlillyart.com)
Kimberley Deng (www.kimdeng.com)
Xiao Qing Chen (www.xqchen.com)

Editors : Jim Thacker and Sara DeGonia
Contributor: Chris Oatley

Published by
Design Studio Press

www.designstudiopress.com
info@designstudiopress.com

10 9 8 7 6 5 4 3 2 1
Printed in China
First edition, October 2017
ISBN: 9781624650369
Library of Congress Control Number : 2017948565

BEYOND THIS BOOK:

Use a smartphone or tablet to open a QR Reader app
and scan this QR code. It links to my Recommended
Resources webpage, which features my recommended
schools, online tutorials, websites, DVDs, and books
featured in this book, but with up-to-date, clickable
links and in-depth descriptions. No smartphone or
tablet? No worries. Just visit this URL:
www.eliottlillyart.com/BBWCA_Resources

TABLE OF CONTENTS

INTRODUCTION

—

Welcome to the second installment of The Big Bad World Of Concept Art For Video Games. The first book, **An Insider's Guide For Students,** provided an honest, concise look at what it takes to become a concept artist in the video game and entertainment industry. Created for students and aspiring artists, it covered how to find the right school, how to get the most out of your education, how to properly prepare your portfolio to land your first job, and more.

How to Start Your Career as a Concept Artist is book two in the series and will be diving even deeper into the subject matter. It is a guide for the upcoming professional, or any other artist interested in joining the entertainment industry. That includes students who are about to graduate and enter the workforce, young professionals who have just broken into the job market, individuals who are currently working in unrelated fields, but want to make a career change, and even existing professionals who are frustrated with their situations and need help figuring out what comes next.

If you are a student and haven't yet picked up a copy of An Insider's Guide for Students, I highly recommend you do so first, as a lot of what is discussed here piggybacks on ideas introduced in the original book.

DISCLAIMER

—

This book is rooted in my personal experiences as a concept artist working in the video game industry. Most of what I write about is based on things that have really happened to me over the years. However, everyone is different, and each artist is on his or her own path. What has worked for me may or may not work for you.

Being a firm believer in hard work, dedication and discipline, a lot of the advice I offer in this book will require similar degree of focus. Since my definition of success is "when preparedness meets opportunity," I always try to be ready for anything, and my advice to you will be to do the same. For some people, this may seem excessive. But that's OK. Even if you only apply part of what you've learned, you will be better off for it. Keep in mind that "success" isn't likely to happen overnight, but will be seen through small incremental improvements as a result of smart choices.

I should also note that while I consider myself a talented individual, there are a lot of other people out there who do what I do, some with even greater success. However, unlike most artists, I have taken the time to document the process as honestly, unflinchingly and thoroughly as possible, using my own experiences as a teaching tool. As such, I consider this document to be a work in progress: one to be expanded upon and refined over the course of my career.

If the lessons I've learned can prevent someone from making a critical mistake, or help them negotiate a better salary, or even just save them from a bit of grief, my efforts will have been worthwhile. It has taken me a decade to figure all of this out, but my hope is that by reading this book and the one before it, you will be able to get to the place where you want to be in life more quickly than I did myself.

A BIT ABOUT ME

—

After I graduated from New York's School of Visual Arts in 2006, with both my BFA and MFA in illustration, I started my career as an "in-house" concept artist and lent my talents to the visual development of several projects, including F.E.A.R. 3, RAGE and DOOM. I have since left the studio life to pursue my interest in teaching, writing and creating my own personal projects. I still take on freelance work for the video game and entertainment industry, and I specialize in environment, vehicle and weapon designs. As a freelancer, I have worked on several titles within the Call of Duty franchise: most notably, I was responsible for designing the majority of weapons in Black Ops 3.

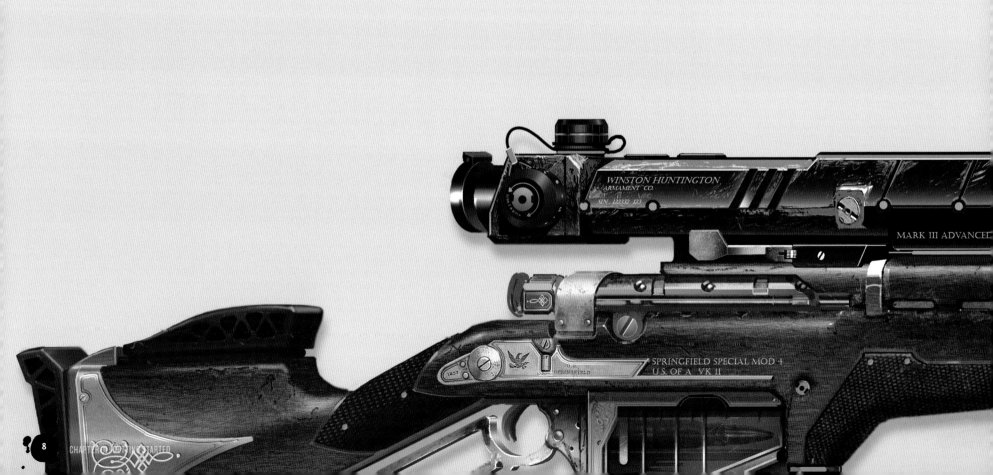

- CHAPTER 01 -

GETTING STARTED

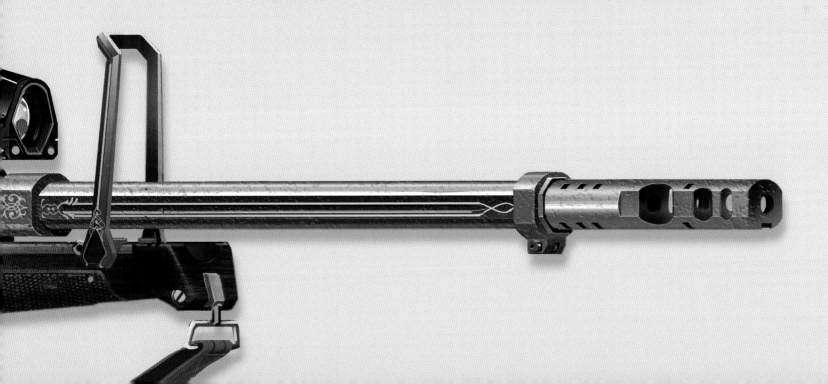

THE TRUTH ABOUT CONCEPT ART

Thirty years ago, the idea of making a living as a concept artist was almost unheard of. However, recent advances in computer-generated imagery have created a surge in demand. Modern CGI is now so complex that entertainment companies don't just need artists to create the images seen on screen: they need artists to plan what will be seen on screen, too.

Originally, the term "concept art" referred to working drawings of assets that were to be created for a movie or video game, like digital characters, vehicles or props. These blueprints were used only by the internal production team, and were rarely seen by the public. But over the past decade, there has been a growing tendency for companies to use concept art for marketing as well as planning. Concept images are now used to generate interest in upcoming titles: in magazines, in forums and on websites.

As a result, concept artists are now in high demand. Entire careers can be launched by a single image going viral on the internet. But the process has also skewed public perception of what the job entails. Since a studio wants to show its product in the best possible light, only the very best of its concept art will be released publicly.

Although they make for great "art of" books and portfolio pieces, such full-color, highly rendered pieces are rare. Most concept artists' day-to-day work is centered around quick sketches and rapid iterations. Concept artists need to be great thinkers and problem-solvers—not just great renderers.

As much as I would love to show my professional work in this book, the nature of concept art prevents me from doing so. By definition, the work that a concept artist creates does not belong to him or her : it belongs to the company that commissioned it, and cannot be reproduced without that company's permission. Instead, I can show you my personal work, and hope that it motivates you in the same way.

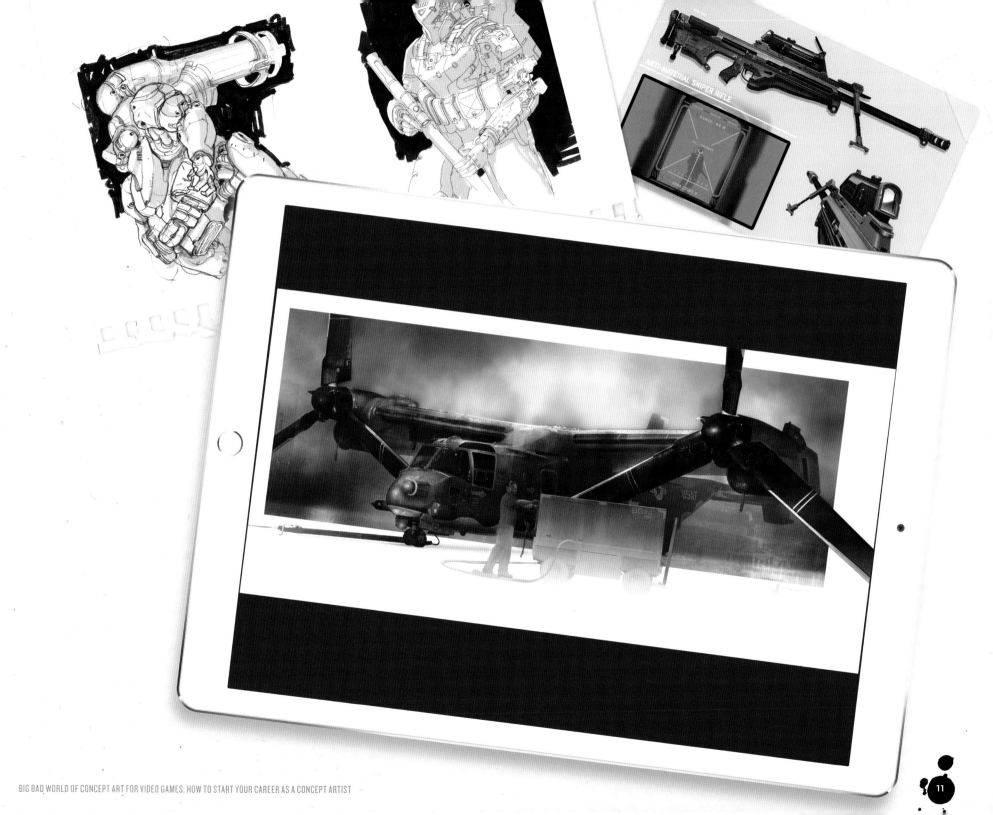

ANTI-MATERIAL SNIPER RIFLE

THE DIFFERENCE BETWEEN A JOB AND A CAREER

When you are starting out, the tendency is to "shotgun blast" your portfolio to every studio that is hiring and take the first job that is offered. While this can be a good way to get your foot in the door, it isn't a good long-term strategy. Making a successful career is about more than just getting a job.

A job is something that you do to earn money. You show up, put in your hours, then collect your paycheck and leave. It may not be related to the job you did previously, may not offer many networking opportunities, and may only be temporary.

A career is a series of jobs directed towards an objective. It's an all-consuming passion: something that you can pour yourself into. It's full of lessons that you can apply directly to your next role, comes loaded with networking opportunities, and reflects your long-term life goals. Making a career is much harder than getting jobs.

Here are some points to remember about jobs and careers.

EVERY JOB IS PART OF YOUR CAREER

Good, bad or ugly, the companies you work for and the games you work on will define your career. Every successful project that your name is attached to makes getting the next job easier. But every poor or unreleased title is a blemish on your résumé. Have too many of them, and you may make salary negotiations harder for yourself.

EVERY JOB TEACHES YOU TRANSFERRABLE SKILLS

Although the circumstances may be different, the lessons you learn working at one studio will prepare you for the challenges to come at the next. Working in the industry, you will often hear people say things like: "When I was working at my last company we would do things this way, and it helped us out. Maybe we should try something like that here."

EVERY JOB OFFERS NETWORKING OPPORTUNITIES

You never know where life will take you, so you never know when or how you will run into people you met earlier. That junior concept artist you worked with may become an art director years later. If working with you was a positive experience first time around, they may want to hire you again.

EVERY JOB DESERVES YOUR BEST

Rarely is it a good idea to just do the bare minimum. Whether or not you think your current job deserves that level of commitment, do more than is asked of you. If you approach your work with a positive attitude and a willingness to learn, you will begin to set yourself apart from your peers, and your employers will take notice.

This book is designed to get you thinking about your goals and the choices you make, so that instead of taking just any job, you take the right job.

SETTING CAREER GOALS

The sooner you establish what you really want from your career, the happier your working life will be. The following exercises may help you clarify your career goals, and to formulate a plan that will enable you to achieve them.

WORK OUT WHAT MOTIVATES YOU

Obviously, something has lured you to this industry. It could be your desire to work at a particular studio or on an ambitious AAA video game franchise. You may find that you are in it for the artistic challenges the job offers on a daily basis, or simply for the money. Perhaps your reason for joining the entertainment industry is to be a part of something bigger than yourself. Be honest when identifying what is important to you, and then spend your career making calculated efforts to obtain it.

LEARN FROM EXPERIENCE

Some artists I know worked on an assortment of projects with mixed success before figuring out which ones really excited them. As you gain experience over time, you will no doubt begin to gravitate towards certain types of projects as well. You may find that you are only interested in working on a specific type or genre of game, like fantasy or science fiction. If so, steer yourself towards similar projects in the future. The sooner you do so, the happier you will be in the long run.

FORMULATE A PLAN

With your career goals identified, you will need a plan to make them a reality. This means evaluating how close you are to achieving your goals, then figuring out what else you need to do to achieve them. For example, if your goal is to work for a specific video game studio, work out what you will need to do in order to make yourself an attractive candidate. If possible, give yourself a range of options: for example, back-up studios to apply to if you can't land your preferred job.

The thing that distinguishes one artist from another is how hard he or she works. That's it. The people at the top of their game don't just work much harder than everyone else: they work much, much harder.

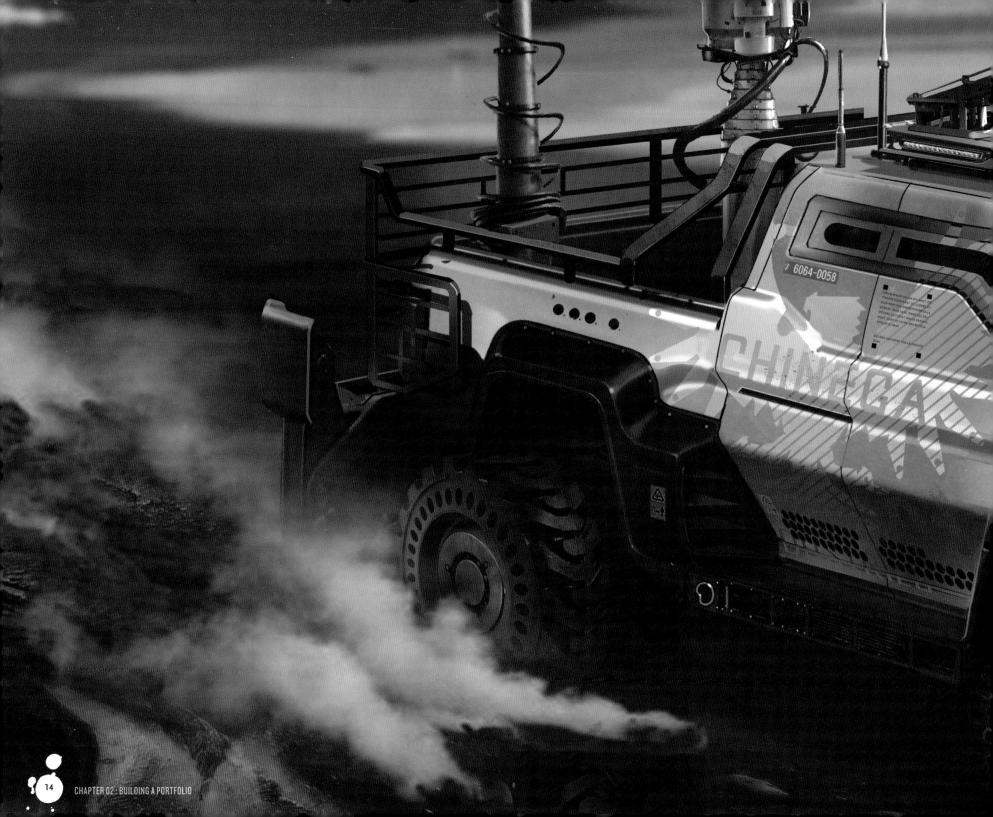

BUILDING A PORTFOLIO

CREATING PERSONAL ARTWORK

To succeed in this industry (and by succeed, I mean secure continued employment), you need to continually create new works of art. Creating personal artwork is not only your chance to define who you are as an artist, but to make a statement to the world about what sets you apart from everyone else. Naturally, there are subjects that you excel at or gravitate towards, but your work should also demonstrate your versatility. Here's how to stand out from the crowd.

DEFINE YOUR PERSONAL VOICE

Every artist has a personal voice: one that matures over time. It is not something that you may be aware of right away, but each image you create brings you closer to finding it. Some people interpret "voice" as "visual style", but it's really something broader: your voice is your own critical interpretation of the subject matter. What does Subject X mean to you? How is that different from everyone else? Finding this kind of hook will help you create images that stand out from the crowd.

DON'T COPY OTHER ARTISTS

To define your personal voice successfully, you will need to detach yourself from outside influences. Don't emulate other artists, even successful ones. Following another artist's ideas means that you cannot be true to yourself, while deliberately trying to adopt a style that someone else has pioneered makes you a "knock-off artist". Remember that you want your own personality to come through in your work: it is what will make it unique.

BUT DO COMPARE YOURSELF TO THEM

The best way to determine whether you are ready to enter the industry is to compare a sample of your work to that of an artist who is already established in the field. Examine the samples side by side, and assess how your work holds up. Does it have the right type and consistency of content? Is its visual quality on the same level? Be honest with yourself. If you find it difficult to be objective, you can always ask a professional at a portfolio review event.

FOCUS ON YOUR CAREER GOALS

If you find that your work is all over the place in terms of style or subject matter, keep your career goals in mind when starting a new image. For example, if you want to specialize in designing vehicles, focus on creating the coolest vehicle you can. While you can, of course, draw other things from time to time, keep in mind that it will be your vehicle concepts that land you your dream job, and that this is where you should focus your energies.

While developing your personal voice is all about finding your own preferred style and subject matter, it can be good to demonstrate your versatility too. You can read more about this in Chapter 03, where we discuss the difference between specialist and generalist concept artists.

A FEW PRACTICAL TIPS

:: Don't: be afraid to fail. Keep trying new techniques and design philosophies rather than letting your current skill set stifle your creativity.

:: Do: push through feelings of discomfort when trying to get your work done. Try not to assess if you "like" the piece until it is finished.

:: Don't: be disappointed if you produce an image that doesn't turn out as you intended. Give it time to grow on you, and get outside feedback before dismissing it entirely.

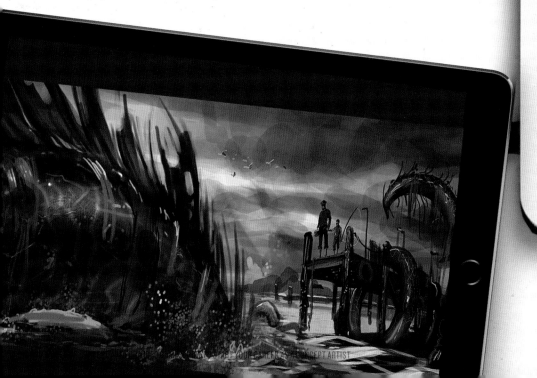

QUESTIONS TO ASK YOURSELF

– How do you want to represent yourself as an artist?

– Who is your target audience?

– Do you aim for realism, or are you more gestural in your technique?

– Do you have a certain style of rendering?

– Do you focus on specific subject matter?

– Are your ideas wild and out-there, or realistic and practical?

– Which do you prefer: brainstorming ideas, or creating sexy, fully rendered images?

– What is your greatest strength? Strong design? Solid draftsmanship? Speed?

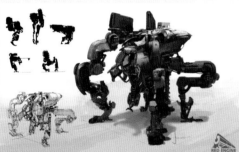

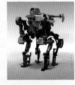

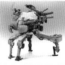

John Park

www.jparked.com

Ian McQue

www.mcqueconcept.blogspot.com

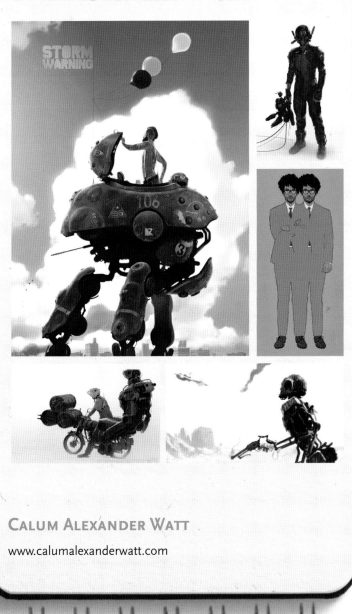

Calum Alexander Watt

www.calumalexanderwatt.com

Here are a few examples of artists who have their own distinct personal voice and artistic style. When you see their work, you instantly know it's theirs. They own their own artistic spaces, and it is refreshing to see what they come up with next.

Feng Zhu

www.fengzhudesign.com

"CHEATING" IN ART

Every professional concept artist will be tempted to "cheat" at some point in their career, although they might not even know that they are doing so. Let's look at the ways of speeding up the process of creating concept art that the industry finds acceptable, and those that it does not.

ACCEPTABLE CHEATS

Acceptable "cheats" are primarily technical shortcuts. Common examples include downloading and using other people's custom Photoshop brushes, "photo bashing" stock 2D images together, or incorporating rendered 3D models into your images.

When I was first starting out, I was hesitant to use these shortcuts as I felt that, somehow, they made my art less "pure". But production art isn't fine art. It will never hang in a museum, nor be sold for thousands of dollars at private auctions. It has no value outside the project it was generated for.

As production artists, we don't control the subject matter we depict, and we can rarely challenge social constructs. As such, I no longer think that we need to concern ourselves with remaining artistically pure—in fact, I believe that the ultimate concept artist is one who can deliver high-quality work the fastest, using any means necessary to get there.

That may be hard to accept, but it's true. In concept art, nobody cares how you got to the end result: they only care whether it looks awesome.

UNACCEPTABLE CHEATS

The exception to this rule is plagiarism. Incorporating another artist's work into your own, then claiming ownership of the result, is theft. It's the fastest way to lose the respect of your colleagues, and can seriously harm your career. Even "borrowing" heavily from another artist's work—for example, creating your own version of one of their images—will be frowned upon. It isn't quite a mortal sin, but it won't earn you any points for originality.

FAKING TILL YOU MAKE IT

Some other cheats fall into a gray area. Imagine that you are struggling to design an environment. You surf the web for inspiration, and find an image that you like. If you trace the perspective and rough placement of the objects in Photoshop, then remove the image, you can fill the space with your own elements, using the tracing as a compositional guideline.

Like sitting in a museum and copying a Rembrandt, this method can help you understand the decisions the original artist made, so that you can apply these lessons to your own work. I call it the "fake it 'til you make it" technique. But be aware that you are walking a fine line. Don't take anything directly identifiable from the original image: only study its high-level design choices.

THE PROFESSIONAL PORTFOLIO

It is a good idea to keep a time log for each of your portfolio pieces. Having an accurate idea of how long it takes you to create an image of a particular type helps you set realistic timetables when discussing projects with recruiters or HR staff, and is useful information to have on hand in job interviews.

With all of your content in hand, it's time to build your portfolio. This should reflect both the skills you have to offer and the job you are applying for. Before we look at the format in which you should present your portfolio, here are a few general points to keep in mind.

CONSISTENCY BUILDS CONFIDENCE

At its core, the point of a portfolio is to establish absolute trust with a complete stranger. If you want the art director to hire you for a project, your portfolio needs to destroy any doubts he or she may have about your abilities (or lack thereof). The fastest way to get an art director to trust you is to be consistent: to show only high-quality artwork of a style appropriate to the studio you are applying to.

YOU'RE ONLY AS GOOD AS YOUR WORST IMAGE

Art directors tend to judge an artist based on the worst image in his or her portfolio, not the best one, nor an average of them all. To an art director, your worst image reflects the reality of your abilities: the quality of work you are likely to produce in a professional environment. It needs to be good enough to convince an art director that you could successfully complete an assignment if he or she hires you on your worst day, under less than ideal conditions.

LESS IS MORE

In general, it is better to show fewer amazing images than more mediocre ones. Since your aim is to demonstrate consistency, any variation in quality will be counter-productive. Once you lose the trust of an art director by showing him or her an image that is poorly concepted or executed, it may take twice as many excellent images to reestablish that trust.

THE RULE OF FIVE

My personal theory is that you need to show at least five amazing images of the same type in succession before you can earn an art director's trust. Let's say that while looking through your portfolio, an art director sees an amazing character concept. They may think of it as a one-hit wonder. Even if there is a second amazing character concept directly following it, that could be written off as coincidence. The third amazing character concept, however, establishes a pattern and begins to hint that you might actually be competent at characters. The fourth amazing concept reinforces that notion, and the fifth amazing concept solidifies it. Anything after that is a bonus as the art director now trusts that you can do characters and is confident that the next image will be as solid and outstanding as the last.

FAVOR YOUR COMMERCIAL WORK

Showing actual production art from a game will carry way more weight with an art director than even your best personal image. This is because the professional work testifies to your ability to work under pressure. It enables the art director to gauge what you can produce under typical production conditions, and shows that another studio has trusted you with their own project. If you have any such pieces, clearly label them with the project title and studio name. The date and art director's name are optional.

DON'T MIX PERSONAL AND PROFESSIONAL

If there is a visual divide between your personal and professional work, it may not be wise to put both in the same portfolio. Use your judgment here. If the inconsistency might confuse an art director, either create a second portfolio that only features your personal work, or save it for online galleries.

PHYSICAL PORTFOLIO PRESENTATION

Even in the internet age, a physical portfolio is necessary for those in-person "meet and greets". The way in which you present it says a lot about how much you value your work, and in turn, how much anyone viewing the portfolio should value it. Take the time to do it right.

PLAN YOUR TIME PROPERLY

Creating a portfolio is time-consuming, so be realistic when building it. Document how long (in hours) it takes you to complete a single image. Then, to calculate the time needed to make the rest of your portfolio, take that number and add one third as many hours again as a buffer in case "life" happens along the way, then multiply by the number of images you aim to include in your portfolio. This is the approximate total time you will need to allocate to build your portfolio properly. With this information in hand, you can schedule how many hours each day need to be put into building your portfolio to have it ready by X date.

PHYSICAL OR DIGITAL?

A few years ago, there was only one way to display your artwork in interviews: to print out the images and present them in a physical portfolio. But recent improvements in the quality and affordability of iPads and similar mobile devices have made it much more common for artists to present their work digitally. We'll look at the relative advantages of physical and digital portfolios in a minute. But if you do decide to present your work on a tablet, make sure it has a screen at least 10 inches in size. By no means should you attempt to show your portfolio on a smartphone.

WHY CHOOSE PRINT?

:: Traditional, well-established format in which to present work.
:: Lower initial outlay than buying a tablet.
:: Appeals to art directors who like tactile objects.
:: Can display images much larger than most mobile devices.
:: No risk of hardware failure or files corrupting during a presentation.
:: Can be used as "leave-behinds" at events. More on this in Chapter 04.

WHY CHOOSE A TABLET?

:: Slick, clean way to show off your work.
:: Saves you money on print costs.
:: You don't have to worry about color representation and accuracy.
:: Allows you to carry multiple portfolios in one convenient package.
:: Easy to update, modify, and edit.
:: Viewer can zoom in if needed.
:: Shows well in low-light situations.
:: If asked, you can e-mail an image directly to the person interested.

The previous book in the series, The Big Bad World of Concept Art for Video Games: An Insider's Guide for Students, has a lot more information on how to prepare, build and present your portfolio. If you haven't already done so, it's worth reading first.

Here's my professional portfolio held in a simple, 8.5 x 11-inch book, with removable, brown-paper sleeves.

Presentation Tips:

KEEP YOUR IMAGES CLEAN

Don't overcrowd your artwork with too much contact information. All you need to display is a watermark with your website address. This is especially efficient if your URL includes your own name: for example, http://www.eliottlillyart.com.

CONSIDER USING A PRINT SHOP

Consider having your artwork printed at a print shop instead of at home: it can save you money and grief in the long run. You can get some really excellent results from their high-quality color printers, and you don't have to absorb the cost of any prints that come out too dark or that are discolored.

SAVE BOOKS FOR KEY CLIENTS

Another alternative is to get your work published in book format. A quick internet search will turn up companies that do this on demand. Such books are a sleek, sexy, very professional-looking way to present your artwork, but as soon as you create a new image, they become outdated. They also tend to be very expensive. I would only print a very limited number, and only give them to clients who you really want to work for.

THE ONLINE PORTFOLIO

On top of your physical portfolio, it's now almost impossible to do business without an online portfolio. It should contain only your proudest works and should be simple to navigate, clean in design, and professional-looking.

USING GALLERY SITES

The simplest way to create an online portfolio is to upload your images to a website that specializes in hosting artists' galleries. You can find a list in Chapter 10. Such services make it possible to create a professional-looking gallery within a few minutes, and have the advantage that many art directors check them regularly, meaning that getting your work featured on the site's home page can lead to offers of work. Don't post your work on sites whose user base consists primarily of students and hobbyists: it creates the impression that you yourself are an amateur.

BUILDING A PERSONAL WEBSITE

As useful as gallery services are, they will never let you customize your online portfolio to the same degree that you can on your own website. And if they go bust, or get bought up by other companies—which is rare, but has been known to happen—your portfolio may go offline without warning. So invest the time and money and create a personal website that shows off your work to the best advantage.

CUSTOM BUILD OR WORDPRESS THEME?

If you've got the technical skills, you can build your portfolio website from scratch. You can find a list of useful software at http://bigbadworldofconceptart.com/. Alternatively, if coding isn't your strong point, you can buy a ready-made gallery theme for WordPress: a popular blogging platform that also powers some of the world's biggest news websites. Consider themes that support full-screen images and video, and that have support for embedded 3D asset viewers.

BE CAREFUL WITH SITE BUILDING SERVICES

You can also find hosting services that will let you build a site using drag-and-drop templates. The results can look highly professional, but sometimes result in URLs that include the name of the hosting company (typically in the format http://www.yourname.hostingcompany.com). Avoid these services where possible—or at least buy your own domain name and redirect traffic from it to the site—since they can make you seem less professional.

CONSIDER CREATING MULTIPLE PORTFOLIOS

There's nothing to stop you from creating multiple online portfolios, each one serving a different need. Many artists have a personal website that contains a tightly curated selection of their very best work, which they can show to potential clients; but also have an account with an online gallery service where they post a wider range of work. If the need arises, consider also creating a separate, access-protected site where you can post commercially sensitive work, or images that have yet to be cleared for use.

SPRING CLEAN YOUR SITES REGULARLY!

Keep your online portfolio updated with only your current work. Given that most professional artists have several online portfolios, it's easy to find yourself posting your work on multiple websites, and then forgetting about them. While the extra exposure can sometimes be great, it can also be harmful if art directors who Google your name come across old work and think it's an accurate reflection of what you are currently capable of.

Presentation Tips:

ADD YOUR CONTACT DETAILS

People sometimes download images from websites, then forget where they got them from. To ensure that your name will always be associated with your work, make sure each image on your website clearly displays your name and e-mail (or website) address. If you keep work from multiple years, it may also be a good idea to put a date on each image.

DESIGN FOR SPEED

The average art director will spend only a matter of minutes viewing your website, so you need to grab them fast. When building a portfolio website, the artwork should be front and center: don't make visitors click through several other pages to find the gallery. Optimize each image to ensure the site loads as quickly as possible.

KEEP NAVIGATION SIMPLE

Your site visitors should be able to find everything in as few clicks as possible, and with a minimum amount of scrolling. Keep the number of pages down to a minimum, and avoid anything that distracts from the artwork: wordy quotes, affiliate links or background music! Also bear in mind that people increasingly browse the internet from mobile devices, so make sure it's possible to navigate your site properly on smaller screens.

FROM THE MAGNIFICENT MIND OF CHRIS OATLEY

ABOUT CHRIS:

Throughout this book, we will provide valuable interview answers from world renowned designer and educator, Chris Oatley. Since 2005, Chris has contributed artistically to various animated films, television shows, video games and music videos for companies such as Disney, Universal, Hasbro, Electronic Arts, Activision, The Weinstein Company and Geffen Records.

In addition to his Visual Development role at Disney, Chris served as a creative technology consultant, helping to improve the efficiency of the animation production pipeline by creating specialized Photoshop workflows and collaborating in the development of proprietary software tools for the art and story departments.

In 2012, Chris opened The Oatley Academy Of Visual Storytelling. Now he teaches composition, color theory, character design, digital painting and visual storytelling full time. ImagineFX Magazine called him "The best kind of teacher." Many of Chris' students have become professional animation artists or illustrators and consider his teaching to be an essential part of their success. Chris also hosts The Oatley Academy ArtCast - the #1 Illustration Podcast on iTunes, directs The Story Design Conference, paints en plein air as often as possible, sings, plays guitar and writes songs. His life mission is to cultivate empathy and healing in the world through storytelling by educating and empowering visual storytellers.

WHAT DO YOU THINK MAKES YOUR PORTFOLIO STAND OUT FROM OTHERS?

If you want to know what makes your work stand out, just ask the people who have already noticed your work. Ask your social media followers why they like your work. Ask your clients why they picked you. Ask your mentors why they invest their scarce time and energy into your life. My portfolio is much darker now than it was when I worked for studios. I'm most passionate about my melancholic illustration and moody plein air work from the past few years. However, my friends, social media followers and mentors usually respond most strongly to my lighthearted, cartoony character work. I do both because I, personally, value versatility in stories and styles.

WHEN LOOKING FOR NEW EMPLOYMENT, WHAT ARE THE TOP THREE THINGS THAT YOU ALWAYS DO?

Invest, long-term, in relationships with your industry colleagues so all you have to do when looking for new employment is get on the phone. Invest, long-term, in relationships with your social media followers so all you have to do when looking for new employment is make a post. Invest, long-term, in being the best, most professional artist you can possibly be so new employers keep in contact you whether you're looking for new employment or not.

HOW DO YOU SELL YOURSELF DURING INTERVIEWS? IS IT A PRESENTATION (PITCH) OR A CONVERSATION WITH THE CLIENT? WHAT ARE YOUR DO'S AND DON'TS FOR JOB INTERVIEWS?

I have always seen "selling oneself" as an unnecessary complication. I think it makes everybody in the room uncomfortable. People spend money when they feel comfortable. Being uncomfortable has the opposite effect. I have a clear understanding of my own strengths and weaknesses. Usually, all I have to do is tell my story well, clearly, calmly and confidently explain what I know I can deliver and back it up with my portfolio. Passionate referrals from my industry friends and mentors are essential as well.

HOW DO YOU CONVEY "VALUE" TO POTENTIAL CLIENTS?

You can't effectively convey value to potential clients unless you know what your potential clients value. Every studio and client has a different set of values. Blizzard seems to place a higher value on artists who already have ability to work within a specific stylistic idiom. For realistic games like Assassin's Creed, you might find that a portfolio full of historically-accurate, hard surface props and environments is more valuable to the studio. ...and it's probably safe to assume that an "Assassin's Creed" or Blizzard artist might not be a good fit for a cartoony game like Angry Birds - and that's okay. The good news is that you can gain understanding about what a particular studio or client values by analyzing the work they produce. For further clarification, just ask the recruiters, art directors etc.

TELL A PERSONAL STORY OF A POSITIVE BUSINESS EXPERIENCE THAT CAME AS A RESULT OF YOUR DUE DILLIGENCE...

When I worked at Disney I was never the best artist in the room. I promise I'm not just trying to be humble. The years of distance from my time at the studio gave me a more objective view of the work I was producing at the time. It wasn't bad. But it wasn't great. I was certainly doing my best yet I was never the best.

But...In five years as a professional Concept Artist, I went only one day without paid work. My former colleagues tell me all the time that my job security was a result of my rock-solid dependability (see my first response about value), my consistently positive attitude (no complaining) and my willingness to help wherever help was needed (note my wildly varied work history).Care deeply for your colleagues. Make sincere emotional investments in their happiness. Take care of others and others will take care of you.

IF YOU KNOW OF ANY RESOURCE THAT PROMOTE ARTISTIC GROWTH, OFFERS BUSINESS OR LIFE ADVICE AND HAS CHANGED YOUR WAY OF THINKING, WOULD YOU PLEASE SHARE IT WITH US? THIS CAN BE IN THE FORM OF BOOKS, STREAMING VIDEOS, ETC.

"What To Do When It's Your Turn" by Seth Godin

THE ADAPTIVE PORTFOLIO

In his podcast, *Escape From Art Jail* "#5: Designing An Adaptive Portfolio For Conventions & Recruiting Events," Chris Oatley offers some great words of wisdom about creating an adaptive portfolio: a portfolio that can be modified in real time to get improved feedback and results. If you'll be attending industry events or conventions with your portfolio, and if you are expecting to receive feedback from multiple industry professionals, then the adaptive portfolio is a great way to vet your work.

THE TRADITIONAL PORTFOLIO CONCEPT

Many artists are under the misconception that "the portfolio" is a fixed body of work, and once it's assembled, then it's "finished." But, in fact, it can be far more flexible than most people assume.

THE PROBLEM

With a "Fixed" portfolio, there's nothing that can be done to address the comments you are getting throughout the day. This gets embarrassing if you get the same feedback about a particular image several times in a row. It can also urge you to preemptively apologize or make excuses about your artwork to the reviewer. The black portfolio book itself tends to be the go-to portfolio type amongst artists, because it's an inexpensive option, easily available, and "professional" looking. Unfortunately it is also the most generic of portfolio choices, and doesn't say anything about what you have to offer as an artist.

The other option that artists have at their disposal is to have their work self-published and bound in a book format through online services like Blurb, Lulu, etc. These books are beautifully crafted but can go out-of-date quickly, and tend to be unwieldy for the in-person experience. Since they also tend to be expensive, there is a high sense of anxiety about giving it away, or it getting destroyed or damaged throughout the day, etc.

THE ADAPTIVE CONCEPT :

Chris suggests that artists use a simple, inexpensive binder that enables you to rearrange the pages and change the image on the cover. (Any generic binder from an office supply store will work.) He also suggests that you bring more artwork than pages in the binder so you have additional images to swap when necessary. Throughout the day you can try different combinations, based on what people are responding to, and see which yields you the best result. This will provide you with more effective feedback.

Another advantage to the adaptive portfolio is that you can take advantage of unexpected opportunities. For example: If, while attending the convention, you learn that X company is hiring for characters, but you currently have an environment-heavy portfolio, then you can swap out some images for those featuring characters. Lastly, having a simple, lightweight, portfolio means you are less anxious about giving it away. Giving away your portfolio (and never needing it back) to recruiters or HR is better than a "leave behind" because it's your entire body of work, versus a single selected image.

TIPS :

:: Save the fancy, beautiful, and handcrafted portfolio for that specific person or studio for whom you are really passionate about working. To achieve the greatest impact, you can even personalize for them.

:: Remember that a hiring recruiter evaluating you for a job is your main audience. Anyone else who looks at your work may be looking at it for different reasons and therefore may have different or incorrect feedback. Don't try to apply or adapt to everything that everyone tells you—it can become too conflicting. Instead, ask your inner circle of trust to help you filter that information.

:: If you have to drop off or leave your portfolio with a client (which is a rare occurrence since everything is done digitally these days), then it may be a good idea to make it stand out from the sea of other portfolios. Consider putting your best piece (that is representative of your talents and desired position) on the cover of your portfolio, and even, perhaps, on the spine of the book. This also ensures that your work will be seen, even if your book is never opened.

:: Pay attention to nonverbal ques from interviewers. If they blow past an image, then it may not have the desired impact—consider replacing it with another

image. Nonverbal ques can be nonspecific, so, to be safe, show that image to a second and/or third reviewer to confirm the feedback.

:: It can be a good idea to show and compare your portfolio to other artists who are waiting in line with you. It's a great chance to get inspired from what other people are doing. It also allows you to evaluate where you stand amongst the crowd. It can be a sobering moment when you realize there are people in line with you who are better at something than you are, and who are after the same job.

CASE STUDY : MY OWN WEBSITE

My own website (http://www.eliottlillyart.com) uses a simple WordPress template, but it's designed to be as simple as possible to use. I don't keep anything on it that won't make me look good: sketches, works in progress and links to friends' sites are all left for my blog. My portfolio is my own personal place to shine.

LANDING PAGE

My landing page immediately presents you with three options: to view my concept art, illustrations, or The Big Bad World of Concept Art. There is a clear delineation between each, so the viewer has an idea of what kind of work to expect.

PORTFOLIO PAGES

Clicking on an option immediately takes you to a page from which you can scroll through the whole set of images available, and view individual images full-screen. Subject matter is arranged by category, and I only include finished images.

RESUME & CONTACTS

So that potential clients can contact me if they like what they see in my portfolio, the Studio page holds my contact info and mini résumé, along with a button to download my full résumé in PDF format. And that's it: simple, clean and professional.

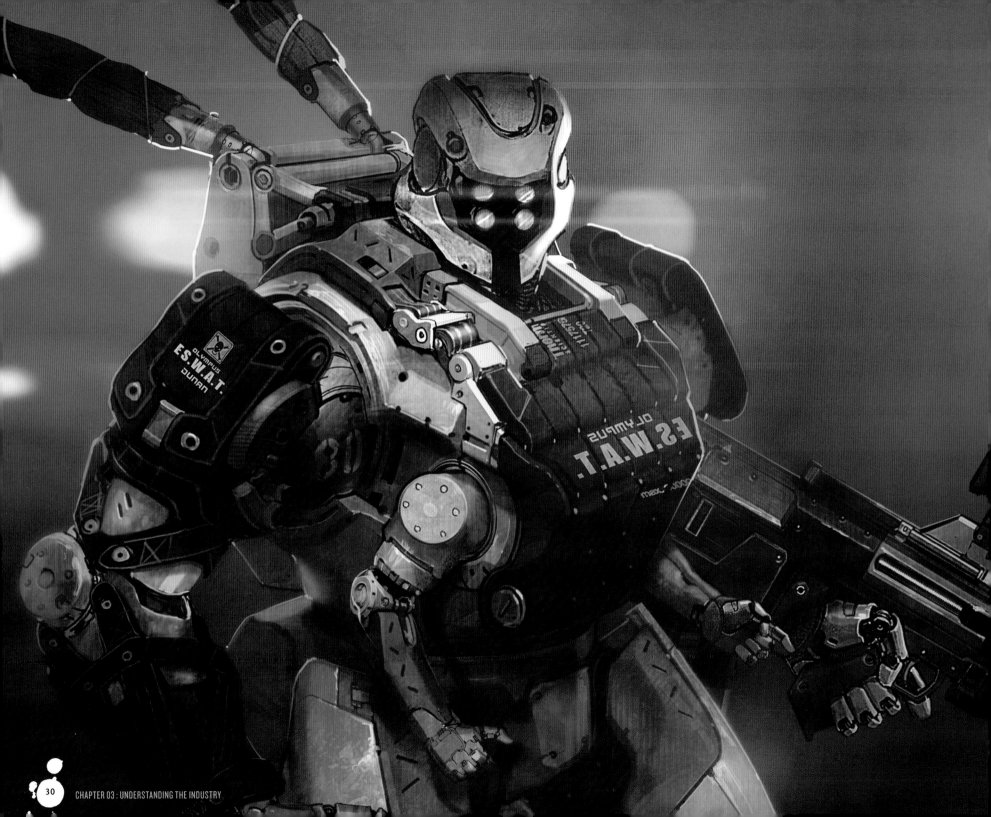

- CHAPTER 03 -

UNDERSTANDING THE INDUSTRY

ARE YOU A SPECIALIST OR A GENERALIST?

To be attractive to a studio, both your skill set and the type of work you create will need to align with its needs. You must have a solid understanding of your own abilities and convey them with clarity, so that a studio can see how it would assimilate you into its production pipeline. As a rule of thumb, when reviewing potential candidates, bigger video game companies with larger teams tend to look for an artist who specializes in one or two specific areas of concept art (for example, characters or vehicles). Smaller companies with limited staff may be more attracted to a well-rounded candidate who can dabble in everything. Let's examine the two approaches. There are pros and cons to each, so it's not a question of right or wrong: more of an issue of temperament.

THE SPECIALIST APPROACH

The specialist approach has the advantage that it enables you to focus on tasks that you naturally do well, or types of images that you particularly enjoy creating. If hired, you will be paid to do the things you love. However, it also carries its own unique risks.

First, the number of studios to which you can apply will be reduced. If you specialize in concepting monsters, there's no point in applying to a studio that creates only sports games.

Second, you will be in competition with other specialists, most of whom will be professionals who are already established in the industry. You will need to be really, really good to beat them.

Finally, if you do land the job, there is a chance that, as the project winds down, and work of your specialist type is completed, you will lose your usefulness to the studio and be laid off.

If you want to become a specialist artist, be proactive in identifying and cultivating contacts at studios that need your chosen style of art. Build a portfolio that showcases your exceptional skills in this area, and highlight any work you have done for other companies specializing in the field.

THE GENERALIST APPROACH

The generalist approach has the advantage that it makes it easier to find work. Being proficient at many things, a generalist is not expected to excel at a specific subject. Although they must be competent and reliable, they will not be expected to have in-depth knowledge of a specific subject area. A generalist can be molded to fill a range of concept art roles at a studio and therefore is more likely to be hired.

Generalist artists are also more likely to be hired as in-house artists, particularly at studios that switch subject matter from project to project. This may appeal to you if you dislike having to change your job regularly, or if you have family commitments that make it harder to move from place to place.

The disadvantage of being a generalist is that you have to be flexible. You may be required to do work that you don't particularly enjoy, or to switch between types of work. If you like to sink your teeth deeply into a task, it may not be the most fulfilling career for you.

If you want to become a generalist, build a portfolio that demonstrates strong general design skills, and your ability to shift gears to match the needs of a project. A good generalist can produce top-notch work in a range of styles and across a range of subject matter.

The Big Bad World of Concept Art: An Insider's Guide for Students examines specialist and generalist roles in more detail. If you haven't already done so, it's worth checking out.

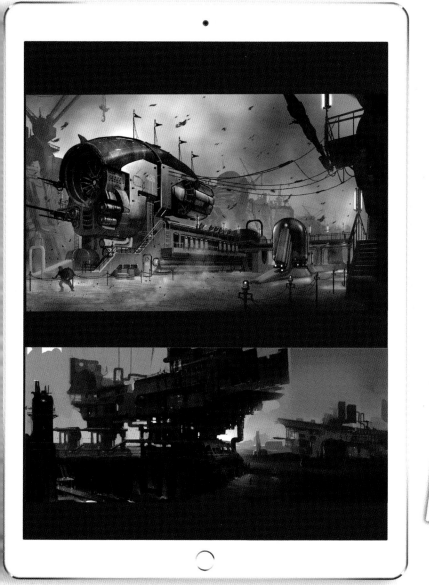

"If you want to become the go-to person for a specific style of art, build a portfolio of work that reflects this. Highlight the work you have done for companies that make use of this art style. If it's a type of work you love to create, so much the better. If not, you will need to put in extra effort to build up enough new images to showcase your abilities."

Tip: Producers, who are usually non-artists, often have a hand in the recruitment process. Lacking direct experience in the field, most of them will simply look at your work and ask: "Does that look like the game we're making right now?" Whichever route you take, your portfolio should be tailored to the position you are applying for, and consistent in quality throughout.

Catch 22: THE NEED FOR PAST EXPERIENCE

Some studios won't hire you unless you have industry experience ... but you can't get industry experience without being hired. You can overcome this by:

– Having a strong enough portfolio that clients are willing to gamble on you.

– Getting someone else to vouch for you. Ideally, this should be someone you know who works in the industry; failing that, someone with power and influence in general.

– Taking on smaller jobs (usually the low-paying ones that nobody else wants) for long enough to build up a client list that proves that you can meet deadlines and be trusted with responsibilities.

– Lending a hand on startup projects where people are grateful for all the help they can get. Be careful: by nature, start-ups are risky companies to work for—doubly so if the founders don't have much experience of working with artists. Get a contract, and ask to be paid half up front, with the balance due upon delivery.

– Focusing on studios that are branching out to multiple projects: they will need to crew up quickly, and cannot afford to be as choosy. Keep an eye on the game industry news.

– Building up contacts in the industry and reaching out to them regularly. You never know when there might be opportunities that haven't been announced: ones for which you may not need to go through a formal recruitment process. For more information, check out the section on networking in Chapter 04.

FROM THE MAGNIFICENT MIND OF CHRIS OATLEY

WHAT TO DO IN THE MEANTIME - WHAT ADVICE CAN YOU GIVE UP-AND-COMING ARTISTS WHO HAVE A PORTFOLIO AND A COLLEGE DEGREE, BUT NO ARTISTIC JOB YET?

"Under-developed fundamentals" is probably the most common problem evident in a portfolio. Also, entitlement and stubbornness seem to be more common problems now than they used to be. There's no substitute for a humble and emotionally generous attitude. When in doubt, draw. ...and don't be a butthead.

Should they pursue other art related jobs (if so, which ones) to enter into the mainstream workforce? Sure. Although "should" is a dangerous word. But any job, art-related or not, that pays the bills and provides work experience is helpful as long as it isn't exploitative or abusive.

HOW PERSONAL STYLE CAN AFFECT YOUR CAREER

Having a distinctive style or "personal voice" for your artwork can be both a blessing and a curse. Studios in need of a distinctive look to help distinguish their games from those of their competitors will deliberately seek out artists who have a stylized body of work. But for other studios, stylization can be a turn-off. Often, a distinctive style will be interpreted as "too cartoony" or "too out-there". If your style doesn't match the art direction that has already been established for a game, or if a studio can't see any way to apply it to a new project, you will be out of a job.

DEXTERITY WITH STYLE

The best way to demonstrate your value to a studio is to showcase your versatility. Every artist has their comfort zone: a range of styles or subjects that they can work on easily, but your ability to break out of that comfort zone, when asked, will directly impact your value to them.

This particularly applies to specialists: if you can't break away from your habitual style, you may end up having to find another project—or another studio—that better suits your abilities. But as you stretch yourself, your comfort zone will expand. And with each project, you will develop a wider and wider body of work. You still need to showcase your specialist skills, but it may not hurt to showcase them in a multitude of styles within your portfolio.

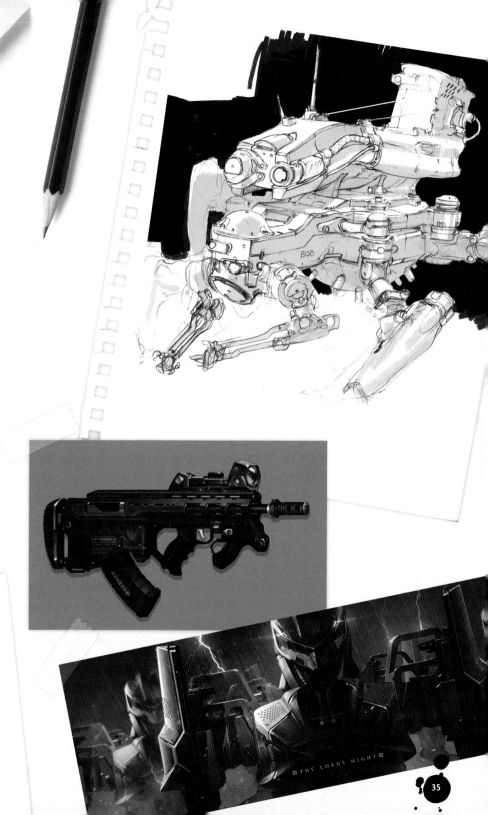

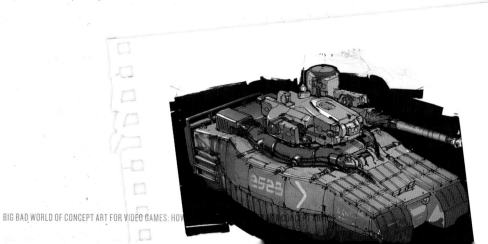

THE RELATIONSHIP BETWEEN STUDIO AND EMPLOYEE

The relationship between a studio and its employees should be professional, healthy and lasting. If this is the case, you can expect to be with a company for a few years—and, with luck, to have shipped a game or two in that time. To make this a reality, it helps to have a firm understanding of your role within the company and, in turn, the studio's role in your career.

YOUR ROLE

The value you have to a company is more than just the artwork you produce on a daily basis. As a professional, you also bring your experiences, your creative problem-solving abilities, and a range of other skills to the workplace.

You also need to be able to work with other people. Your collaborative efforts are, in part, responsible for the success of the project, and therefore the profitability of the studio. How you handle yourself, how you interact with others, and how you find other ways in which you can contribute are all traits that studios look for when assessing how you will fit in with the team.

Being a talented artist is not enough to carry you in this industry. In fact, you can be the most amazing artist but an all-around unpleasant person and no one will want to work with you. Your attitude and personality almost predetermine your success on a project, so stay positive and engaged, and perform your duties to the best of your ability.

THE STUDIO'S ROLE

The studio promises a steady source of income (and other financial benefits) in exchange for your time and commitment to its project. It provides you with the tools and support you need to carry out the work, along with a business plan that it assures it will ship a successful video game by a given date.

No one wants to work at a company that abuses its workers with excessive "crunch" periods, poor management, or outdated facilities. As a professional, you need to ensure not only that you are working on a shippable project but in conditions that are mutually beneficial to both artists and studio.

Good studios provide their employees with constant opportunities for artistic or personal growth, creative outlets for their ideas, and the guarantee that those ideas will be heard. Such studios are usually filled with senior artists and management who will take the time to train and mentor their junior employees. Training is an investment on the companies' behalf, and the ones that do it will usually make the effort to reward and care for their talent so that their investment isn't taken elsewhere.

Getting a job isn't just a matter of knowing the right software. Software skills help, but companies are really hiring you for your ideas and your ability to realize them. The best weapon in your arsenal is not Photoshop, ZBrush or 3ds Max: it's your ability to communicate your imaginative ideas in a tangible way.

THE DIFFERENT TYPES OF GAME STUDIOS

FIRST-PARTY DEVELOPER

A first-party developer is a studio that is owned by a company that manufactures console hardware, like Sony, Microsoft or Nintendo, and develops games exclusively for that company's consoles. First-party developers may also have been independent studios at one point—examples include Rare and Naughty Dog—before being acquired by a console manufacturer. Studios that are only partially owned by a console manufacturer are often known as "second-party developers", as are independent studios that take on contracts to develop exclusively for a single console. If you are worried about layoffs, these types of studios tend to be safer places to work, because they benefit from the financial backing of giant companies.

THIRD-PARTY DEVELOPER

Third-party developers are studios that partner with publishers to develop a title for one or more hardware platforms. (Some large third-party developers may also publish their own games.) Both the publisher and developer have input into the game's look and design, but because it is paying for the game, the publisher usually has final say. Unlike first-party developers, third-party studios have a contractual obligation to deliver new content on predetermined dates, called "milestones". By meeting these deadlines, it proves to the publisher that the game is on target to meet its shipping date. After each milestone, the publisher agrees to pay the studio an advance on its royalties and/or earnings.

INDEPENDENT DEVELOPERS

Independent developers are software developers that are not owned by (or dependent upon) a larger company. They tend to be smaller companies that self-publish their own games, relying on word of mouth and the Internet to advertise. This absence of a parent company means the independent studio can retain full creative control over its work, but that its games may receive less recognition due to the significantly smaller marketing budget and distribution channels.

HOW YOUR CHOICE OF STUDIO AFFECTS YOUR CAREER

When choosing a studio, keep in mind that as well as lending your talents to a project, you are basically investing in that company. Your career becomes intertwined with the success or failure of its projects. If a project does well, you are in a position to benefit, but if it does poorly, its failure may reflect on you—particularly if the studio then has to lay off staff. Here are a few things to consider.

FUTURE OPPORTUNITIES

Rightly or wrongly, when applying for a job, your perceived ability (and therefore, your perceived value) is often directly proportional to the success of your last studio. If you decide to leave a studio at the peak of its success, other studios will jump at the chance to hire you, in the hopes that you will bring some of the magic to your new job. You will often hear things like: "Oh, he's from Studio X, so he has to be good!" Or: "She's just left Studio Y, so she can go anywhere." The better your current employer's track record, the more opportunities you will have when trying to secure your next job.

EXPOSURE

Working on big-name titles means your work will be seen by millions of people. If you are able to promote the work you did on such projects publicly, you are likely to have instant fans—among consumers and industry professionals alike. Companies may view you more desirably or even actively pursue you to join their teams, putting you in the strongest possible position when negotiating your new salary.

JOB SATISFACTION

While you don't have to like every assignment (and you probably won't), the work you are tasked with on a daily basis should be meaningful and engaging for you. You should be able to see how your contributions are affecting the game in a positive way, and to gain new skills and experience. As an artist, your body of work should always be moving forward, not stagnating.

Working at a video game studio is like buying a car: you need to do extensive research, compare the models, and select the one that's right for you. Don't take this decision lightly.

CAREER PATHS

Each project you work on hones the skills required for that project—but only those skills. The subsequent body of work you produce will reflect this. For example, if your job is to concept fantasy environments, you will generate a portfolio that helps you land a job on another fantasy project, but if your real aim is to work on a sports title, you simply won't have the work necessary. Choose each job wisely to ensure you always stay in your preferred line of work.

RISK OF BURNOUT

As artists, we pride ourselves on our work. This pride often defines us as individuals, and therefore needs to be nurtured and protected. If work is a constant string of grueling, stressful, and unhealthy experiences, you may find yourself unmotivated to do anything productive. Negative feelings about the current state of a project, resentment towards management, or anger towards coworkers can all affect how we view, and in turn, value ourselves.

Working for a company at which you experience burnout—or worse, several companies like this—can damage your perception of the industry, and your motivation to be a part of it. I have heard of artists whose entire career consists of canceled projects. After a while, this starts to feel like a curse, and can suck the creativity from your soul.

Relying solely on your job to challenge and fulfill you as an artist is only setting yourself up for disappointment. Seek artistic gratification at home as well, where you are free to be experimental.

A Personal Story:

My first game was set in a modern, photo-realistic world, and I spent most of my time on the project "photo bashing" apartment interiors and city streets. After four years, I had developed a knack for this and became quite comfortable with the process.

The second job I landed was sci-fi-based and futuristic. It required that I design everything from scratch—a task I was ill-equipped to perform because I had spent so long manipulating photos that I had forgotten how to design. Needless to say, the adjustment period was stressful and grueling for me.

My third job was also sci-fi-heavy, but by then, I was already comfortable with designing, and the transition was much, much easier. Noticing the difference in stress levels, I decided then and there that every job I applied for from that point on would be sci-fi-oriented (or would at least require me to design from scratch). I now make it a point to keep that momentum going.

HOW TO CHOOSE A STUDIO

Don't blindly apply to every studio. Instead, seriously consider which studios you want to work for and why. Your first course of action should be to find out everything that you can about a potential employer. Read articles, listen to podcasts, and look on forums to find out what people have to say about the company and its games. Don't be afraid to ask fellow artists if it is a good place to work. This will give you a working idea of how the company operates, but there is still more to consider.

COMPANY SIZE

A big company may offer a higher salary and more benefits in exchange for your services, but working for a smaller company has advantages too. Staff working on smaller projects usually enjoy more creative freedom, since there is less risk associated with them than with multimillion-dollar AAA titles. Employees in smaller studios generally enjoy greater responsibilities too, which, in turn, leads to a deeper understanding of game development. This makes it possible to build up valuable professional and personal skills in a short span of time. Personal achievements are also more noticeable within a smaller company, so when the company grows, you will be well-positioned for a promotion.

WORK CULTURE

Find out how your prospective studio develops its people. Employees are a company's most valuable asset, and enabling them to grow, either through training or simply allowing them creative space, is the key to forming a healthy team. To get the best results, some studios will even allow their employees to explore their own individual ideas for a project. Such creative freedoms aren't common, but aren't unheard-of, either. A working environment like this fosters positivity and high productivity.

ARTISTIC STYLE

When considering whether to apply to a studio, assess how closely the work it produces matches your own, and how laborious it would be to adhere to the studio's preferred art style. If you can't stand the potential headache, it may be better to look elsewhere.

COMPANY LEGACY

A studio may be renowned for a particular title or franchise, and you may want to be a part of that success. If this is the case, make sure that the people who made that franchise great are still at the studio. If they are not, assess whether the studio is still great, or whether you have missed its heyday.

POTENTIAL COLLEAGUES

Research other artists at the company. You may find yourself attracted to a studio because of the amazing talent working on a project. Joining a team full of people who are more talented than you, and who have their own areas of expertise, is a great incentive to excel.

A Note on Art Directors :
What kind of input you will get from
your art director varies dramatically
from company to company. Particularly
at large studios, big-picture folks are
usually stretched to capacity just keeping
all of their bases covered. Often, they
would love to jump in on more production
work, but it's rare that they will go more
than an hour in any given day without an
interruption: an emergency, a high-priority
meeting, a publisher visit, an interview,
and so on. Art directors are usually more
hands-on in the preproduction phase of
a project, when style guides are being
developed, and then are more focused on
reviewing art assets once the production
kicks into high gear.

PROMOTING YOURSELF

MARKETING & SELF PROMOTION

The goal of marketing is to get your work seen by the right people. That generally means art directors, studios that you want to work for, and/or your fan base. The more art directors who know you exist, the greater your chances of getting hired. But how do you go about marketing yourself successfully?

DEVELOP AN ARTISTIC IDENTITY

Before you can promote yourself to other people, you need to understand your own identity as an artist. By now, you should have a firm grasp of your strengths and weaknesses, figured out what makes your work unique, and developed a personal voice. Together, these constitute your artistic identity.

KNOW YOUR TARGET

The next step is to decide on the type of work you want to pursue, which studios you want to work for, and where you might fit in at those studios. We looked at how to do this in the previous chapter.

CREATE A MISSION STATEMENT

Once you know what type of work you want to do, formulate a mission statement for your own personal use. The exercise at the side of this page should help you get started. A good mission statement provides a clear, concise explanation of your value to the studios you wish to work for. As you mature as an artist and gain more experience of the industry, this value may change, so revisit your mission statement regularly, and update it when necessary

START TO PROMOTE YOURSELF

With your mission statement in hand, and a body of work to support it, it's time to start promoting yourself. The Internet is your gallery space: it enables your work to be found even by people who aren't looking for it. As well as your own website and blog, post your work on other professional concept art galleries and forums. Many of them run public art contests, and it's worth entering these as well. Creating tutorials and posting them online is another great way to promote your work. Don't ignore offline media, though: also submit your work to art books and industry magazines.

EXERCISE: BUILD A MISSION STATEMENT

If you're having trouble formulating a mission statement, try writing down the answers to as many of these questions as possible. Doing so will force you to consciously articulate your thoughts, and will provide you with material that you can condense down into the mission statement itself.

– What platforms and types of projects are you interested in working on?

– What skills and experience do you bring with you?

– What differentiates your work from other artists?

– What unique benefits can studios gain from your abilities?

– Why should studios believe that you can deliver these benefits?

PERSONAL BRANDING

When it comes to applying for work, you are your own brand. Branding is the expression of your artistic identity: your unique voice, personality and style. When building a brand, your aim is to present yourself as a true professional, while remaining truthful to yourself.

WHAT TO CALL YOURSELF

When choosing a brand for yourself, I recommend using only your real first and last names: not your online handle, gamer tag or username. Real names tend to be easier to remember than made-up ones, and associating your own name with your work makes it easier for potential employers to find through a Google search. If you have a very long name, consider shortening it or using a nickname for all your professional work.

OWN YOUR OWN DOMAIN NAME

If possible, register your own name as a domain name for a website or, if it has already been taken, register a domain that includes your full name: my own website is http://www.eliottlillyart.com, for example. As well as looking more professional on your résumé than a link to a third-party gallery website, it means that your URL is the only information you need to watermark into portfolio images.

DESIGNING A LOGO

You can take personal branding one step further by creating a logo for yourself. It should be simple, instantly recognizable, and easy to read at a small size. Your logo should be used consistently on everything you do, including the work in your portfolio, your résumé, cover letter, invoices, and business cards. You can see my own logo to the right; it is designed in monochrome, and there are alternate versions with black and transparent borders, making it easier to use it on a range of different-colored backgrounds. I use it across everything I do: as a watermark on portfolio images, and on my website, my résumé, and my promotional materials..

You don't need to do any personal branding to become a successful concept artist. Most people will recognize your work long before your logo. But I find that it helps to ensure continuity between your artwork and your business, and creates an aura of professionalism. At the very least, it won't hurt your chances of getting a job.

In addition to a logo design, choose a font to use consistently across your website and all of your documentation.

BUSINESS CARDS & POSTCARDS

Do concept artists really need business cards? Yes and no. In my opinion, actual business cards are a bit formal for concept artists, unless you're freelancing, in which case your client base will be more used to receiving them. But it's important to have something that you can hand out at conventions, seminars, or interviews, as a keepsake for anyone who is interested in your work. As a compromise, try printing up postcards: people are more likely to keep a large image that they can pin up on the wall.

WHAT SHOULD I INCLUDE ON MY CARD?

Your postcards should feature your artwork—make sure you choose images that are popular among people you respect—and your contact information. Don't include information that will quickly become dated, like your street address: stick to your name, e-mail address, and portfolio website.

SHOULD I PRINT BOTH SIDES?

Don't let the printing company advertise on the back of the postcard: pay the extra price for printing on both sides, and use the space to promote yourself. As well as putting your full contact details on the back of the card, I suggest including your e-mail address or URL on the front. That way, if the card is pinned to a wall, the recipient can see how to reach you without having to take it down.

HOW MANY SHOULD I PRINT?

You don't need that many mailers right away—your artwork will get better and the images you have chosen will quickly become outdated. Starting out, I recommend printing a hundred or so to keep costs down, and seeing how things go.

SHOULD I CREATE MULTIPLE DESIGNS?

Some online print services allow you to print a single batch of cards with varying images on each one. These services cost a bit more than printing a single image, but offer you more flexibility. If you have multiple skill sets (for example, 3D modeling and concept design), you may want to create a separate design for each skill set. Bring both with you wherever you are showing your portfolio, and leave behind whichever card the potential employer favors.

I had these postcards printed when I was still at college. At the time I had no clue how many to order, so I ordered 5,000 (which was about 4,500 too many). I currently use the surplus as free handouts when I lecture at events. Although they don't represent my current body of work, they present a consistent brand, and provide students with a tangible example of a leave-behind.

Wondering where to get postcards printed? You can find a list of on-demand printing services in Chapter 10.

Things like stickers and fridge magnets can also make great handouts at events, or during interviews. You will pay a bit more to have them printed, and some people consider them gimmicky, so experiment and see what works for you.

MAILERS

In this age of digital downloads, cloud storage, and online streaming, it's refreshing to get tangible objects in the mail. Sending a postcard, pamphlet, or even a printed book of your work to an art director can be a great way to get noticed. If your mailer is handmade, even better: it shows that you took the time to create something specifically for them, and showcases your craftsmanship.

TAILOR YOUR MAILER LIKE YOU WOULD YOUR PORTFOLIO

When creating a mailer, research the studio's target audience and art style. If you don't already have them, create samples of work that match its own games. The whole point of the mailer is to show that you understand the company's intellectual property, and can replicate its house style.

PERSONALIZE YOUR WORK

Search online for existing mailers, study their design and layout, and adapt them to your own needs. Get creative with materials, sizes, and decoration. When you are done with your designs, always personalize the mailer even further with a quick handwritten note—or at the very least, your signature.

ADDRESS THE ART DIRECTOR DIRECTLY

Address the art director directly by name. If this isn't possible, address it as: "Attention Art Director". (This is less than ideal, since the mailer may or may not get to its intended target, but is better than addressing it to the studio in general.) The best way to find the name of the current art director is to ask a buddy who works for the studio, but if you aren't fortunate enough to have a direct connection, try looking on the company website, or on professional networking sites like LinkedIn. You may even find his or her name listed in books and magazines, or in the judging panels for art competitions.

GET THE ADDRESS RIGHT!

Make sure you have the studio's current address before sending anything out. If you spent a lot of time preparing your mailer, you may also want to get a tracking number so you can ensure that it gets delivered safely. Even if you don't, you should still follow up two or three days later with the studio's receptionist to see if it reached its intended recipient. (Don't harass them for feedback or to speak to the art director: if you created your mailer correctly, they will get in touch with you.)

I used these mailers when I first got out of school. They were also great leave-behinds at conventions.

Don't generalize. A mailer is a personal communication between you and an art director. Including a set of unrelated images isn't showcasing your versatility: it's showing that you haven't done your research.

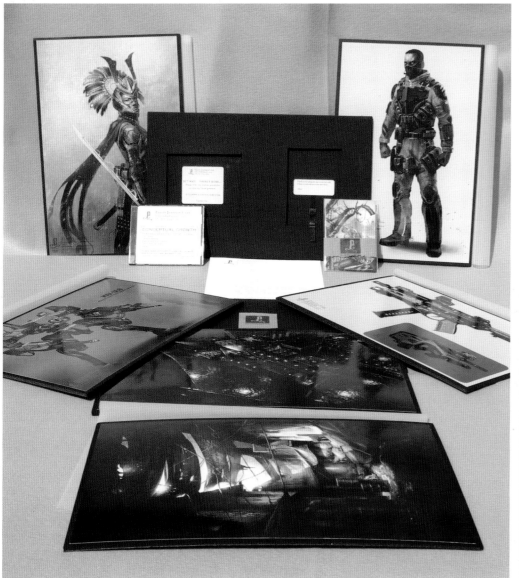
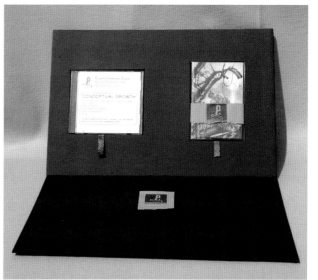
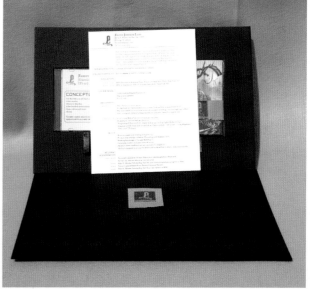

This is an example of a mailer that I sent to Activision. It consisted of six 11 x 17-inch full-color prints, mounted on quarter-inch-thick black foam core. As well as my résumé and cover letter, I included a CD with additional images, plus a few stickers, postcards and mementos. The package was crafted to showcase my work in the best way possible, and clearly took time and effort to make. I didn't get the job, but my contact within the studio said that the art director really liked my work and hung it up on the wall of his office.

NETWORKING

Another aspect of marketing yourself is to network in person. As well as helping to make yourself known in the industry, networking is one of the best ways to find out about upcoming opportunities, sometimes before they are advertised publicly. There are several different ways to do so.

CONNECT WITH ART DIRECTORS AND POTENTIAL CLIENTS

When networking with the people who hold the jobs, it is best to try to develop a casual, friendly rapport. Don't go straight to talking about business every time you see them: you may come off as desperate to get something out of the relationship. A good practice is to drop them a line before you actually need work, updating them with a new image every few months or so.

CONNECT WITH OTHER PROFESSIONALS

You should also be connecting to other artists in the industry via social networks, online galleries, and forums. Form a relationship with them by following their blogs, commenting on any pieces they post publicly, and by sending them the occasional quick e-mail. Every artist benefits from being part of a network of professionals who look out for one another, so reaching out to other artists can create a healthy long-term bond. This can be as simple as trading workflow tips, or as direct as asking feedback for advice about specific studios, or news of upcoming job opportunities.

CONNECT WITH YOUR PEERS

The people you meet in person are artists too. So keep in touch with them. Drop your former classmates and colleagues a line occasionally, checking in on how things are going. Genuine interest will help keep you fresh in their minds.

CONNECT WITH YOUR FAN BASE

One of the best ways to increase your public profile is to post training material: tutorials, podcasts, YouTube videos, and so on. Having people following you online is also a great motivation to get new work out on a consistent basis.

Even blogging can be a great way to showcase your sketches and works-in-progress. Blogs are incredibly quick to set up, and don't involve a fee. When creating a blog, it is good to have a general idea of who it is that you are creating it for. (Fellow artists? Fans? Art directors?) Once you know your audience, engage with them directly. If someone comments, be sure to respond in a timely manner: it will encourage other people to participate. Stick to a consistent schedule of posts (once a week, once a month, or whatever you can manage) to encourage people to keep coming back.

CONNECT WITH STRANGERS

Get to know anyone who takes an interest in your work, even those who seem to have no bearing on your career. They may be friends with an art director, have a contact who is in a position to hire, or know about an upcoming opportunity. You just never know. Plus, it's always good to get to know your fans; use social media to stay in touch with people.

WHY IS SELF-PROMOTION SO IMPORTANT?

In theory, you don't have to do any of the things discussed in this chapter to get a job. You could simply wait until a position is advertised, then send in your folio. Marketing yourself actively takes time and effort, and doesn't guarantee you a job at the end. So why is it important?

EFFORT COUNTS

If two candidates apply for the same job, both coming from good studios, and both with outstanding portfolios, the same work-related experience, and great personalities, the only thing that is left to differentiate them is their levels of professionalism. If one candidate takes the time to put together a complete marketing package, whereas the other candidate does not, the first candidate may have a higher perceived value. Self-promotion won't hurt your chances of getting a job, only help.

RECOGNIZABILITY COUNTS

The other value of marketing yourself is that it increases your recognizability. People are far more likely to remember your work if they have some sense of who you are as a person. This is why it is better to network directly where possible. When you talk to another person face-to-face, your personality is front and center. It also gives you a chance to read the other person's reaction to you, and assess how your pitch is going. Once you have done so, you can tailor that pitch on the fly according to what you now know they want.

TIPS :

– How you behave online can also harm your chances of getting hired. The Internet never forgets, and once posted, your comments linger indefinitely. Watch what you say and how you say it, and always remain professional. Don't post anything that will hurt your reputation or otherwise tarnish your brand.

– It is extremely helpful to know how people found you, so, when approached, always ask them to reveal the source. They may have come across your work on websites, stumbled upon your blog, or got a referral from a friend. If you find that a few sites are primarily responsible for promoting your work, focus your time and energy on those sites going forwards.

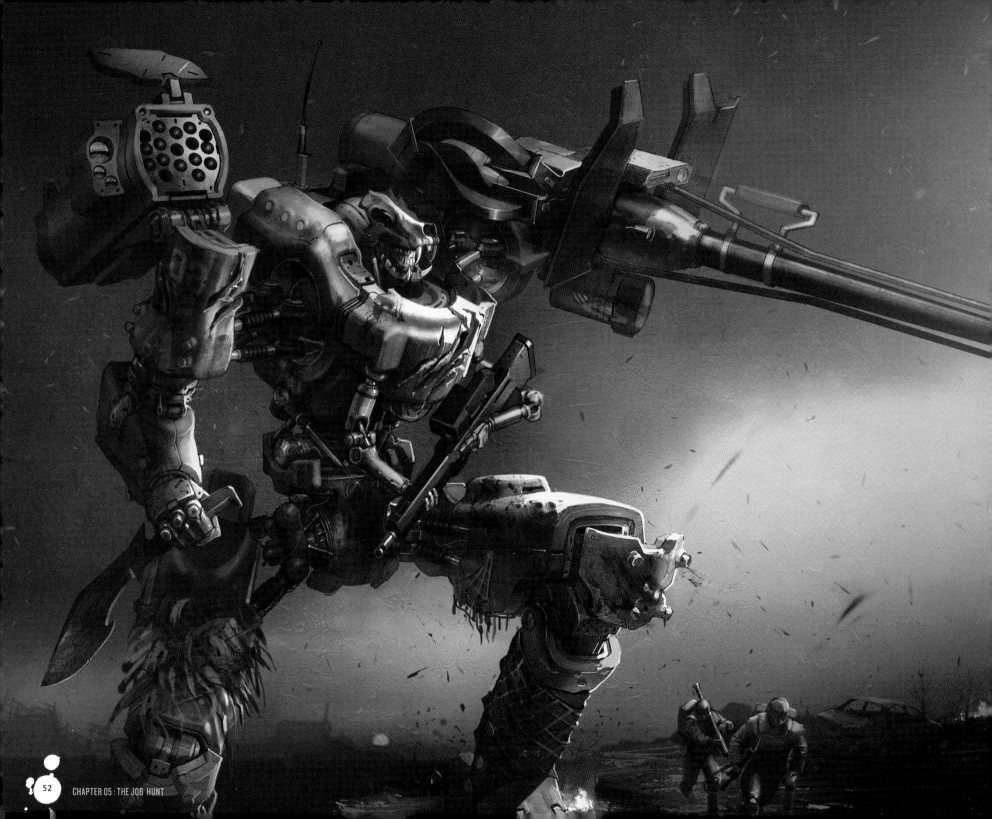

- CHAPTER 05 -

THE JOB HUNT

WHERE TO LOOK FOR JOBS

Because there is no single place that houses every job listing, you will need to be diligent and persistent in your efforts in order to find the latest vacancies. Take advantage of every resource at your disposal to land you the gig you want. Here are a few common ways to track down current full- and part-time jobs.

ON COMPANY WEBSITES

Video game studios often list available positions directly on their websites or their social media profiles. Unfortunately, there is no consistent schedule for when jobs will be posted, so you should check back frequently. Because tracking jobs in this way can quickly become tedious, it helps to be selective about which studios you target and keep track of when you last checked for availability.

ON JOB BOARDS

Studios also announce their open positions on video game-related websites and forums. Such sites usually provide a listing of current full- and part-time opportunities, their requirements, and the correct department to contact at the studio. When responding, make sure you read the instructions carefully.

THROUGH ONLINE JOB AGGREGATORS

You can also sign up for newsletters and subscription services that will notify you when a new job is listed in your chosen field. Their reliability is "iffy", but they can highlight types of opportunity that you hadn't thought about before.

THROUGH THE BUDDY SYSTEM

Often, the best way to find a job is through a colleague who already has a job at the studio where you want to apply. Your buddy will usually know that the studio is looking for new talent way before the company makes this fact public. This inside information can put you first in line. Another benefit to having a buddy on the inside is that he or she can answer your questions, guide you through the art test and interview process, and be your champion in the studio—all greatly improving your chances of getting the job. It's also worth mentioning that companies usually offer referral incentives to their employees. This means that if your buddy refers you for the job, and you get hired, he or she gets a finder's fee. Everybody wins.

THROUGH DIRECT CONTACT

If you don't have a buddy on the inside, you can still reach out directly to people who work for the studio to ask if there are any open vacancies. We'll discuss this in more detail next.

THROUGH RECRUITERS

It's also possible to use specialist recruitment agencies to find jobs for you. Because recruiters work with video game studios on a regular basis, they often know about vacancies that haven't been advertised publicly. You can find out more about them later in the chapter.

THROUGH OPPORTUNITY HIRES

Most companies practice "opportunity hires". These are cases where a candidate comes along who is so talented or experienced that the studio will create a position specifically for them. This is a rare occurrence, and requires the moon and stars to be in perfect alignment, but it can happen. We'll talk more about how to get your work in front of art directors at industry events later in the chapter.

You can find a list of recommended job-hunting resources in Chapter 10 of the book.

HOW TO FIND A JOB THROUGH DIRECT CONTACT

If you don't know anyone who works at the studio you want to work for, you can still try reaching out directly to inquire about open positions. As the online equivalent of "cold calling", this is a bit of a long shot, but if you do it correctly, it can't hurt your chances of a job, only help.

WHAT YOU SHOULD DO

If you can, find the contact details of art directors or human resources (HR) representatives who work at the studio, then e-mail them directly. Make sure you spell their names correctly. Be cordial, professional, and brief, and show humility and gratitude. Always include your own contact information and attach a few samples of your latest work. You can also include a link to your portfolio site, but don't assume that the person that you are contacting will take the time to visit it.

HERE'S WHAT YOU SHOULDN'T DO:

Don't write an entitled e-mail like this:

> Hey XXXX,
> Check out my portfolio: www.whatever.com.
> Thanks, John

Art directors and HR representatives are spammed by dozens of applicants a day, and e-mails like this will be deleted almost immediately. If you haven't taken the time to craft a proper introduction and briefly explain your interest in the studio, why should they take the time to help you?

HOW TO FIND CONTACT DETAILS

A company's e-mail addresses usually follow a consistent format, so providing you know at least one e-mail address and the full name of the person you are trying to reach, you can usually work out the rest. If you visit a company's website, the "Meet the team" section may include the names of key staff. You can also beat one of its video games, and read the credits at the end. Lastly, you can search on professional networking sites like LinkedIn.

HOW OFTEN TO CONTACT ART DIRECTORS

If you contact an art director and don't hear back, don't contact him or her again until you have significantly improved your artwork. Leave a minimum of three to six months between communications. Don't send the same stuff. If one didn't like it first time, one won't like it the second time either.

HOW TO FIND JOBS AT VIDEO GAME CONVENTIONS

Often, when a studio has a game on display at an industry event, expo, or convention, there will be someone from HR present at its booth. Getting face-to-face time with a studio representative is the best way to make a lasting impression, since they can assess not only your work but your personality. Consider it a mini-interview. If things go well, that person will become your contact at the studio, and may help push your candidacy along.

DO

:: Project an air of confidence in your work.

:: Ask the person you talk to for his or her business card or contact details. Even if they don't have a job to offer you now, you can always send more work later on. The person will be more inclined to give you a card if the interaction went well; less so if it didn't.

:: Carry enough handouts and keepsakes to pass out. I may only pass out 10 to 20 postcards, but I typically bring about 50.

:: Seize an opportunity. If you are walking by and see a booth that interests you, stop in and say hello. Introducing yourself and learning more about the studio can only help your chances of finding work.

:: Look for booths with small or no crowds in front of them. Long lines usually indicate a well-known studio, but lesser-known studios need artists as well—and if you're a young professional, your chances of getting hired at a smaller company may be greater than at a larger one.

DONT

:: Appear overly eager. Don't say that you will do "anything" for a job. Doing so makes you sound desperate and ignorant of how the game industry works. Instead, be specific about your strengths and abilities.

:: Argue with whoever is reviewing your portfolio. If they make a comment that you don't like, or disagree with, simply nod your head and thank them for the feedback.

:: Try to explain or defend your work. (Being able to take criticism is part of the job, and if the person reviewing your portfolio senses confrontation, he or she may be put off.)

:: Show your artwork off on your phone! A ten-inch tablet is the minimum screen size to use.

PACING YOURSELF PROPERLY

Get a lot of rest the night before an expo. (Easier said than done, I know, but try anyway.) You will be on your feet all day, and the back-and-forth shuffle can be exhausting. On the day itself, get to the venue early. Things move very slowly at these events, and there is often a long line to meet with the studio representatives. The best time to present your work is first thing in the morning, or right after lunch. By the end of the day, company representatives will have seen hundreds of portfolios and will be tired, probably grumpy, and definitely ready to go home.

If you are staying at the expo for several days, I suggest that you practice your interview skills on one or two companies that you don't really care about first. Once you have gotten the hang of the process, you can approach the companies you really want to work for. If possible, leave your dream studio for last, when you are really in the swing of things—but bear in mind the note above about not leaving it to the end of the day!

Expos tend to be dimly lit, so be prepared—you may need to bring a small light to help show off your work. If you are showing work on a tablet, you won't have this issue.

HIRING A RECRUITER

Recruiters are basically headhunters working to fill job openings at studios. They act as matchmakers of sorts, pairing individuals who seek employment with companies that are hiring. Recruiters typically have a large list of jobs they are trying to fill, and are always scouting for qualified people to fill those roles. If you are new to the industry, you will probably have to seek them out, but once you have a few years of experience, they may approach you directly.

HOW THE RECRUITMENT PROCESS WORKS

Recruiters usually begin by conducting a portfolio review. If they like your work, they will shop your portfolio around to studios on your behalf, and if your talents match a studio's needs, will facilitate your employment within that studio. Some recruiters will charge you, the client, a fee for their services; others charge the hiring studio. Each recruitment agency will have different policies and contracts, so if you decide to go down this route, do your research first. Here are some pros and cons to think about.

PROS

:: A good recruiter can help tailor your portfolio and polish your résumé to match the needs of specific studios. Some recruiters will even prepare you for interviews by sharing their knowledge of that studio.

:: If you are shy, or are uncomfortable handling business matters, using a recruiter to manage your application can help minimize stress.

:: A recruiter will fight to make sure you receive an industry-standard salary.

:: Working with a recruiter frees up time to focus on your current job, or on developing your portfolio.

:: Recruiters have access to a huge network of industry contacts, and will know of job listings before they are posted publicly.

:: Recruiters usually only get paid once you are placed at a job, so it is in their best interest to find you a job quickly.

CONS

:: A recruiter typically has multiple clients, and you may not be their top priority.

:: By relying solely on a recruiter, you will miss out on valuable networking opportunities. Developing the skills and experience needed to network successfully can lead to opportunities further down the road, so the sooner you start, the better.

:: Because there is a fee involved, studios are hesitant to use recruiters to fill entry-level positions.

:: Despite their connections, there is no guarantee that a recruiter can find you a job that matches your interests, or even a job at all.

:: Because they get paid when a position is filled, a bad recruiter may try to pressure you into attending interviews that don't match the job you are actually looking for.

WHEN TO LOOK FOR JOBS

Finding the job you want isn't just a matter of looking in the right places: it's also a matter of looking at the right times. Timing your job search correctly can greatly improve your chances of getting hired. Here are the best times of year to look for new jobs.

FIRST THING IN JANUARY

It can be difficult to find employment during the fourth quarter of the year: things tend to slow down around Thanksgiving and Christmas, as a lot of the key decision-makers are on holiday. Look for jobs in January, once everyone is back in the office.

THREE MONTHS BEFORE BIG TRADE SHOWS

Sometimes studios will ramp up staff to meet deadlines for major industry events like E3. This means that job positions will be posted a few months earlier.

WHEN A BIG TITLE IS ANNOUNCED

Follow the rumor mill on gaming websites to see if there is any mention of an upcoming, unreleased game that you want to work on. If it's still in its early stages, the chances are that the studio will be in need of concept artists.

AFTER A BIG TITLE HAS SOLD WELL

Similarly, if a game shipped a few months ago, do some digging to determine how successful it was. If it has sold well, there's a good chance that there will be a sequel in the works. At the very least, DLC content will need to be made. This is another indicator that the studio may be hiring.

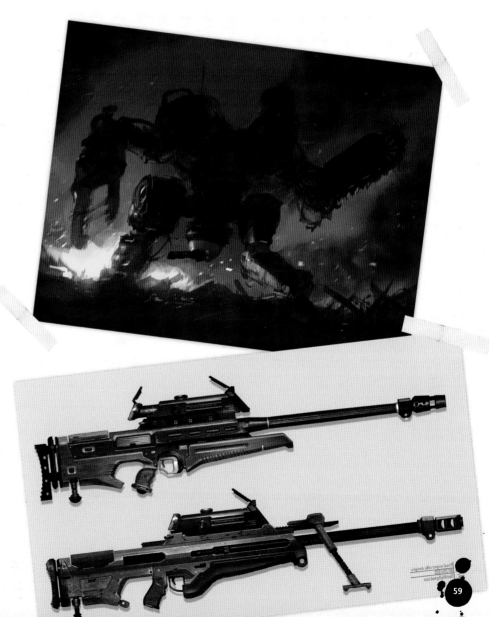

A Personal Story:

Fresh out of school, the first video game studios I applied to were LucasArts, Blizzard Entertainment, Electronic Arts, and Day 1 Studios. Despite having a solid portfolio, the only one to make me a job offer was Day 1 Studios. Ten years on, I now realize why none of the others called me back.

At the time, Blizzard was making high-quality, cinematic-driven titles and I had nothing in my portfolio that looked like what they were working on. LucasArts was looking for senior talent (people with several more years of industry experience than I had). Electronic Arts was looking to hire a specialist to fill a unique role within their company, but I was more of a generalist at the time.

Of the four companies, the only one whose requirements I met was Day 1 Studios, and that was the one I ultimately got a job with. So my first mistake was simply to apply to the wrong studios.

I did not know it at the time, but the second mistake I made was to accept the first job offer I got without considering the work I would be creating. I was hired to work on modern-day survival horror games—a topic I knew nothing about. Had I taken the time to research the companies and truly understand what they were looking for, my career might have headed in a different direction.

HOW TO CHOOSE WHICH STUDIO TO APPLY TO

If you have followed my advice so far, by this point, you should be very knowledgeable about the companies to which you hope to apply. Here are a few practical considerations that may help you narrow down your final shortlist.

KNOW THE STUDIO

If you are seriously considering applying to a studio, make sure you are familiar with its past games, and, if possible, the title it is currently working on. Evaluate the studio's track record—does it put out games ever year, two, or three? How good are those games, and how well do they sell? Does the company benefit from being part of a larger network of studios, or is it independent? Is it a first-party developer or a third-party developer? How many projects does it have in development simultaneously?

QUESTIONS TO ASK YOURSELF

:: What type of game do I want to work on (first-person shooter, massively multiplayer online role-playing game, action/adventure, and so on)?

:: What genre of game do I want to work within (fantasy, sci-fi, modern day, and so on)?

:: Am I open to working at any type of studio (first- or third-party)?

:: Am I willing to relocate?

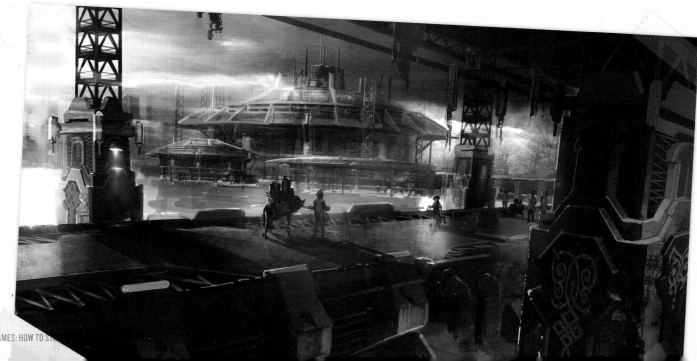

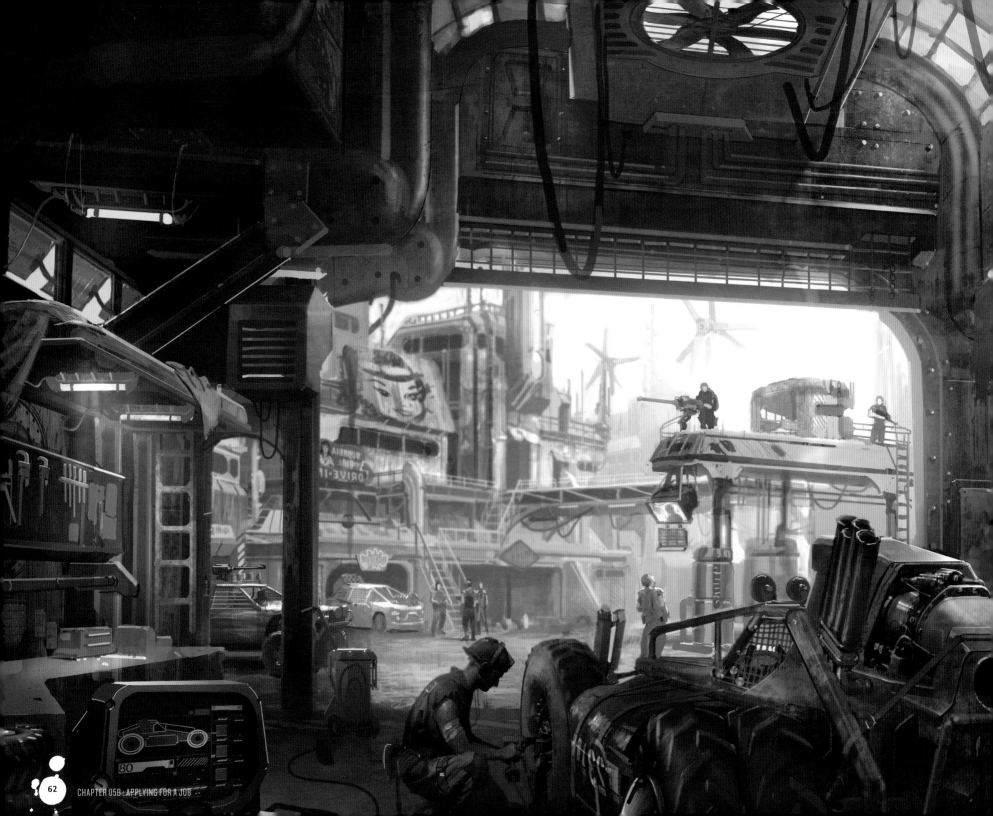

- CHAPTER 05B -

APPLYING FOR A JOB

APPLYING FOR A JOB

Once you have found a vacancy for a job that you like, it is tempting to fire off your current portfolio, then sit back and wait for a reply. Don't do this. Spending a little more time preparing and tracking your application will greatly increase your chances of success.

BE REALISTIC ABOUT WHAT YOU APPLY FOR

Only apply for jobs that match your skill set—don't apply for positions where the work in your portfolio is irrelevant to the job for which you are applying. It is also a waste of your time to apply for senior positions if you are new to the industry.

CHECK THE MINIMUM REQUIREMENTS

When hiring for an intermediate-level position, it is very common for employers to prefer a candidate with at least two or three years of industry experience. They may even suggest that the applicant should have a specific number of shipped titles under his or her belt. Requirements like this indicate that a studio is looking for a candidate who is intimately familiar with game development, so while internships usually count towards the total, they may not be the experience that the company is really looking for. But read the wording carefully: if the guidelines are only suggestions, newbies can still apply.

ASK AROUND BEFORE YOU APPLY

If you know someone who works at the company, talk to them before you apply. They may be able to give you a sense of what it's like working there, what the studio is looking for in that position, and who will be most influential in deciding who gets the job. If your contact is well-respected at the company, their own recommendation may carry a fair bit of weight.

TAILOR YOUR SUBMISSION

Don't send a standard portfolio and cover letter to every job you apply for. Tailoring your submissions to match the needs of the studio or project you are applying for will help you stand out from the crowd.

KEEP RECORDS

Keep track of the studios you have applied to, which images you sent them, and who your contact there was. Also note down whether there was any feedback, and tailor your next application accordingly.

REAPPLYING ONLINE

If you are applying to a large company directly through its website, you may be asked to upload your portfolio and résumé. Once a new vacancy becomes available, the HR department will review all of the candidates they have on file to see which ones have suitable skill sets, and contact them directly. If you don't hear back, wait until you have new work to show before resubmitting your portfolio. You should leave at least six months between submissions.

WHAT TO DO IF YOU CAN'T GET A JOB

If you have applied for several jobs for which you meet the minimum criteria, but are struggling to get an interview, the simple fact may be that either your work or the way you present yourself needs to improve. Accept this, and then correct it. Humble yourself, buckle down, and return to the basics.

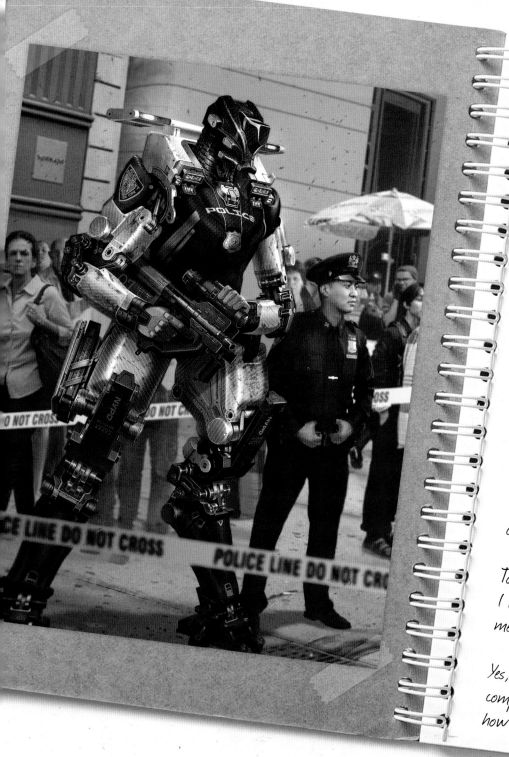

A Personal Story:

When the time came to move on from my first job, I applied to a range of studios online at the same time. This meant that I had to compile a separate body of work to upload to each studio's website. After doing a bit of research on their past and present titles, I came up with a plan to target them all individually. The goal was to show them that I was familiar drawing the things featured in their games and that I had the chops to match.

To Naughty Dog (makers of the Uncharted series) I uploaded a slew of interior and exterior environment concepts focused on lighting, color, and mood. They depicted cities overrun with vegetation, abandoned towns, hidden temples, and so on.

To Infinity Ward and Treyarch (makers of Call of Duty series) I sent far fewer environments. Instead the bulk of the images I submitted were concepts for weapons, vehicles and soldiers. The environment concepts I did send were focused on war-torn city streets and destroyed buildings.

To id Software, wanting to work on either DOOM or RAGE, I uploaded all my sci-fi concepts—with the result that they offered me a job. The first project I worked on was RAGE itself.

Yes, there was a bit of overlap in the images I sent to each company, but they didn't know that. This is a good example of how to tailor your portfolio to match the job you want.

CREATING A COVER LETTER AND RÉSUMÉ

As well as your portfolio, your job application should include your résumé and a cover letter. You can incorporate parts of your mission statement into both. There are a lot of websites that explain how to create a professional résumé, so I won't cover the process here.

In many ways, your cover letter is more important than your résumé, because it is your chance to sell yourself to the company. It should introduce your skills, emphasize how they meet the company's needs, and explain how you can help the company realize its goals.

Let's look at an example of a real cover letter—and then how it could have been improved.

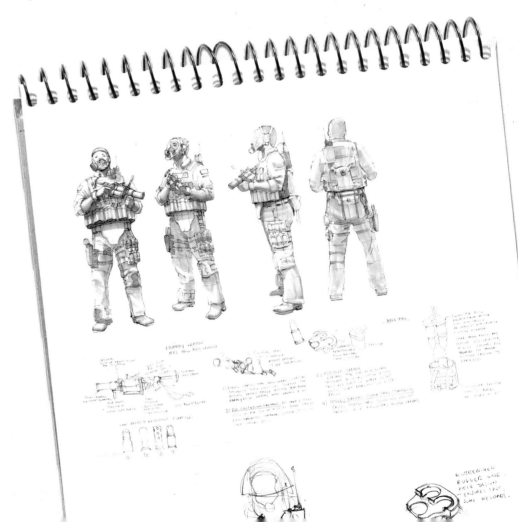

You can incorporate parts of your mission statement into your cover letter and résumé.

A REAL COVER LETTER

Dear Ms. XXXXX

I've noticed your posting on XXXXX (website) and am extremely interested in hearing about the current opportunities within XXXXX (studio). You will definitely need highly motivated and talented artists to fuel the creative process at your company, an ability that is paralleled to my own.

Although I technically only have two years of professional experience, I have worked diligently for this opportunity to make substantial contributions to the XXXXX team. I understand that your video game company prides itself on creating games that are revolutionary and groundbreaking in software developments, while making advancements in the art of game design itself. In my artwork I painstakingly challenge myself to create rich, immersive worlds with descriptive characters and vivid settings, and it is that same drive to do bigger and better things that has become the hallmark of XXXXX. I believe that I meet all of your requirements, and my portfolio will easily reflect my ability to do a comparable level of work.

I am coming from an illustrative background and will be graduating from the School of Visual Arts with my MFA in May. I will be available to work full-time after May 31st and am willing to relocate to Chicago, or wherever my talents may be needed to pursue my career. It is serendipity that this opportunity comes now. If you are looking for a concept artist who will make an immediate and positive impact upon your company, I would like to explore this opportunity. I know I can bring with me a wealth of talent and enthusiasm as well as the ability to meet deadlines in a professional environment. Please expect a follow-up e-mail by next week.

I look forward to hearing from you to discuss employment possibilities. Please view my online portfolio at http://www.eliottlillyart.com and feel free to e-mail or call me at the contact info below. My résumé can be viewed in the attachment file. Thank you for your consideration. I look forward to hearing from you soon.

Sincerely,
Eliott Johnson Lilly

This cover letter is a bit long-winded. At the time I had Googled "how to write a cover letter" and was following a template that I found. The letter worked, but, in hindsight, I could have been more direct and straightforward in my approach.

Hello Ms. XXXX

I am extremely interested in filling your open concept art position at XXXX (studio). With my two years of professional experience, I believe that I am a highly motivated and talented concept artist who can make substantial contributions to the team and help fuel the creative process.

I understand that your video game company goes to great lengths to develop games that are revolutionary and push the boundaries of console technology. In my artwork, I too am constantly pushing myself to create truly immersive worlds. We share a similar drive to do bigger and better things than what is expected of us, and for that reason, I believe I meet all of your requirements, and that my portfolio will reflect my ability to do a comparable level of work.

On June 1st, I will be graduating from the School of Visual Arts with my MFA in Illustration and will be willing to relocate to pursue my career. I know I can bring with me a wealth of talent and enthusiasm that will make an immediate and positive impact upon your project. Please view my online portfolio at http://www.eliottlillyart.com. My résumé is attached.

I look forward to hearing from you. Please expect a follow-up e-mail from me next week.

Sincerely,
Eliott Johnson Lilly

This cover letter is more to the point. It introduces me, my interests and my reasoning in applying for the job much faster, and summarizes the potential benefits of hiring me more concisely.

Résumés should be no longer than a page and contain only essential information. Be sure to list your key accomplishments, publications, and any work that has been featured in gallery exhibitions or on game covers.

UNDERSTANDING ART TESTS

If a studio is interested in your work but is unsure whether your talents are a good fit for its projects, it will usually send you an art test. This is a chance for you to apply your creativity to a task you might actually face in production. Let's look at how this process works.

WHAT TO EXPECT

The art director will assign you something specific to draw that relates to the position for which you are applying. For example, if you are applying to be a character concept artist, you can expect to design a character. You may even be supplied with a few reference images to set a visual target for the work. Regardless of any external obligations, you are usually expected to complete the assignment within a limited amount of time.

A REAL CASE STUDY

Over the next few pages, you can see an example of a real art test. It was the first one that I did out of college, and while it got me the job, my inexperience definitely showed. First, we'll look at the brief, then at what I produced in response. We'll look at what I did right— and what I could have done better.

THE BRIEF

Here is an example of an art test from an art director:

Concept Artist Test: Character
Task: Put together a color ortho concept of a modern urban military/SWAT-type character (either male or female).

General guidelines:
:: Don't go too sci-fi or cartoony.
:: He can be slightly heroic in proportions, but the character should work in a fairly realistic-type game.
:: The goal is to show us the characters' basic proportions, what gear they're wearing, some amount of facial detail, as well as an overall sense of how much finish you put on a piece like this.
:: These would be templates for the modelers to build off of, so accuracy between the views is important.

Submit a .jpg file of your final horizontal page with the color Front/Side/Back views lined up on one page. If you have any questions, please contact me.

Good luck.

HERE'S WHAT I PRODUCED

The image on the next page shows my final submission for the art test. I have positioned the character in the frontal, 3/4 view, side and back profiles. At the time, this is what I thought "orthographic" meant – it does not. The piece took me a couple of days to complete and turned out pretty well, but with hindsight, there are things that I could have done better. Let's look at what I did right, and what I did wrong.

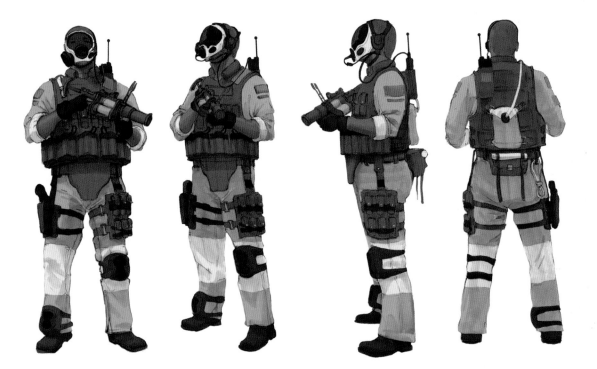

NON LETHAL COMBATANT:

Employs low velocity, "less-than-lethal" rounds to incapacitate personnel or material, while minimizing fatalities, permanent injury to personnel, and undesired damage to property and the environment.

Deployed in an urban environment to control civil unrest, this soldier's primary weapon is the Multi Purpose Launcher (also known as the M.P.L.) Which chambers three 45 mm rounds of various ammunition. Built for tight spaces and rigorous missions, this launcher utilizes the maximum amount of firepower while occupying the least amount of space.

Concept Artist test – Character
ATTN: ART DIRECTOR

ELIOTT JOHNSON LILLY
Please visit www.Eliottlillyart.Com
(P) 917.224.13.33.

THINGS THAT I DID RIGHT

:: When drawing the figure, I used photographic reference of myself holding a tube.
:: My design of the character is solid and thoughtful.
:: The main requirements are met.
:: I gave the character a backstory, which justified his kit and weapon.
:: I paid attention to detail, and I personalized his loadout (for example, the asymmetrical knee pads, rolled-up sleeves, and the shoulder patches) to give the concept a "lived-in" feel.
:: Over delivered on what was asked by providing a weapon concept that further complemented the soldier and his back story.

THINGS THAT I DID WRONG

:: Failed to understand the term "orthographic." An "orthographic turnaround" is a means of representing a 3D object in only two dimensions. It should be devoid of perspective—the character should be exactly face-on or side-on to the viewer—and points on the subject should line up exactly across each view. For example, the pouches on the character's thigh should be at the same height no matter which angle they are viewed from.
:: Generally, in an orthographic view, the character should be in a "T" or "A" pose.
:: Facial detail is covered by the gas mask.
:: The character is floating on the page. (It needs to be grounded with a shadow).

As well as designing the character's suit, I included a breakdown of the primary weapon and its features, including sketches of how the gun reloads, and of various types of ammo held in specially made pouches. The accompanying text identifies each piece, explaining how it relates to the next, and how everything works together. Looking at this image, the art director can clearly tell that I have given the concept some thought, and would be able to explain my ideas to the team.

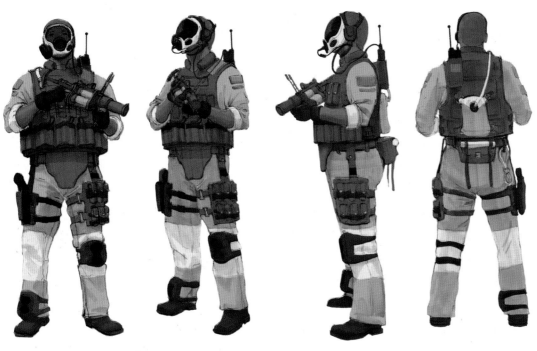

NON LETHAL COMBATANT:

Employs low velocity, "less-than-lethal" rounds to incapacitate personnel or material, while minimizing fatalities, permanent injury to personnel, and undesired damage to property and the environment.

Deployed in an urban environment to control civil unrest, this soldier's primary weapon is the Multi Purpose Launcher (also known as the M.P.L.) Which chambers three 45 mm rounds of various ammunition. Built for tight spaces and rigorous missions, this launcher utilizes the maximum amount of firepower while occupying the least amount of space.

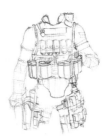

PRIMARY WEAPON: M.P.L 45 mm M406 LAUNCHER

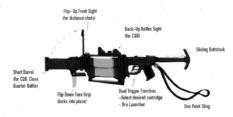

Flip- Up Front Sight
(for distance shots)

Back-Up Reflex Sight
(for CQB)

Sliding Buttstock

Short Barrel
(for CQB; Close
Quarter Battle)

Flip Down Fore Grip
(locks into place)

Dual Trigger Function:
-Select desired cartridge
-fire Launcher

One Point Sling

Launcher cylinders open like revolver. Accepts various 45 mm cartridges. (see below)

Low Velocity Projectile: Examples

AMMO:

1. GAG 'RENADE
Liquid capsule that upon impact shatters, smearing black liquid on surface. The rising vapors cause intense vomiting and other bodily excretions to occur, paralyzing victims who breath it in. Victims must immediately be medically treated.

3. AIR CONCUSSION GRENADE:
On impact; implodes and sucks 80% of air from room. One capsule per 30 sq.. ft. Used indoors only.

Rubberized retention grip holds grenades firmly in place.

'NADE - PULL

Canister

2. HYDROGEN GRENADE:
Propelled capsule containing a hydro/nitrogen mixture, is triggered mid-air by user. Capsule explodes and compounds fuse with oxygen in air to produce a large quantity of water under immense pressure. One capsule is strong enough to knock down anything within a 35 feet range. Because steam is a by-product, victims can suffer up to third degree burns.

4. SMOKE/ TEARGAS- PEPPERSPRAY COMPOUND:
Causes momentary blindness/ loss of breath and involuntary muscle spasms.

'Nade - Pull allows for quick release from canister. Lift straight out using rubber handle. Precisely made to align with launchers cylinder chamber.

Once 45 mm rounds are placed into launcher, a quick sideways pull releases retention grip without spilling the cartridges.

Reduces reload times to 2.2 seconds

Modular canister: can be placed any where on vest/ gear.

HOW TO PASS ART TESTS

Art tests can be stressful, which means that it's easy to overlook important details. Here are some points to bear in mind, along with some practical tips for success based on my own experiences applying for concept art jobs.

READ INSTRUCTIONS CAREFULLY

As well as challenging your creativity and testing your level of commitment to a project, art tests are designed to test your ability to follow instructions. Make sure you understand what is expected of you, and deliver on those expectations. Pay close attention to the details.

DON'T BE AFRAID TO ASK FOR HELP

If you have questions, ask for answers—don't assume anything. Asking for help is a good way to establish a rapport with the art director. Communication is extremely important in game development, and if you correct your course according to the answers the art director provides, it shows you can handle feedback. But be smart: art directors are busy people, so stockpile as many questions as you need answered and you can and ask them all at the same time.

ESTABLISH THE DEADLINE

Find out up front when the art director expects the art test to be turned in. If he or she is not specific and says something like "in a few weeks", you generally have two weeks; three at the most. If you are expecting a conflict in your schedule (being out of town, for example), you should raise the issue before you accept the assignment. You may have to do a bit of negotiating here.

Although expectations vary from studio to studio, submitting a test in under a week is generally considered to be fast; inside two weeks is considered to be on time, although

you won't win as much kudos for speed; and if you haven't handed anything in after three or four weeks, red flags will start to be raised, since this usually indicates that you are struggling with the assignment.

Naturally, the sooner you can hand in the assignment, the better, but don't sacrifice quality for speed. It is better to deliver an amazing image in two weeks than a mediocre image in one week.

BE RESOURCEFUL

Use any and every tool at your disposal to create the best image possible. But bear in mind that you're working against the clock. Don't waste precious time trying to learn a new software program, or fumble with a technique which you are not comfortable. Similarly, plan your work before starting out; be smart with your use of time. To paraphrase an old saying: "Think twice, cut once."

REMEMBER THE COMPETITION

Keep in mind that just because you have an art test in hand, does not mean that the company will stop its search with you. There may be more than one artist taking the same test at the same time, who is fighting for the same job that you are. Assume that the other artist is doing an amazing job, and act accordingly: spend all the time you need to make your submission extraordinary.

GET FEEDBACK BEFORE YOU SUBMIT

Remove all doubt about the quality of your work before you submit it. If you have to ask, "Is this good enough?" you already have your answer: "No." Show it to people whose artistic opinion you trust, have them give you as much constructive criticism as possible, and then make any changes necessary.

OVER-DELIVER IF TIME PERMITS

It's good practice to deliver more than what was asked of you. For example, if you are asked to design a character, think about delivering designs for additional props, like weapons or gadgets. These not only add interest to your character but provide good opportunities to show off your skills in other areas.

However, you should only attempt to do this after your main task is complete, and then only if there is additional time available. Make sure that whatever else you deliver is as top-notch as the art test itself—including additional mediocre concepts or unfinished thumbnail sketches will raise questions about your artistic judgment, and can actually hurt your chances of being hired.

KEEP TRACK OF YOUR EFFORTS

Keeping track of how many hours the test took you to complete is a good idea so you can gauge how long similar assignments will take you in the future. Some art directors will ask you to do this as part of the test itself.

STAY IN CONTACT

It is a good idea to update the art director on your progress every week or so. This lets him or her know that you are making progress on the image and are still on target to meet the deadline.

ASK FOR EXTRA TIME EARLY

If you have to ask for more time to complete a test, it is best to do so before you actually need it. If you have spent two weeks on a test, and can already see that you will need at least another two, notify the art director immediately. Waiting until you are already late reflects poorly on your time-management skills, and if it turns out that you don't actually need the extra time, no one will be upset.

Only do this if it is absolutely necessary. As time drags on, the art director will either develop higher and higher expectations of your image, or will begin to worry that you are struggling with it. The worst thing you can do is take four weeks on the test only to hand in a lackluster image.

Another danger of taking additional time to submit your art test is that it increases the chances that another candidate will submit first. All it takes is for another person to submit work of equal or better quality in a shorter time, and you will have lost the job.

SUBMIT IN THE CORRECT FORMAT

When you are ready to send in your work, make sure that it is in the correct file format (JPEG, TIFF, etc.) and that you are sending it to the correct e-mail address. It is also helpful to add a note in the e-mail asking the art director to confirm that they have received the test.

INCLUDE YOUR CONTACT INFORMATION

It is also a good idea to include your contact information on each image you submit (name, e-mail, and phone number), as well as the name of the art director.

Because art tests can play such a huge part in an artist's career, I take each one very seriously. As soon as a test comes in, I halt all of my plans, tune out every distraction, and—I have to admit—may even call in "sick" at work to gain the time I need to complete it.

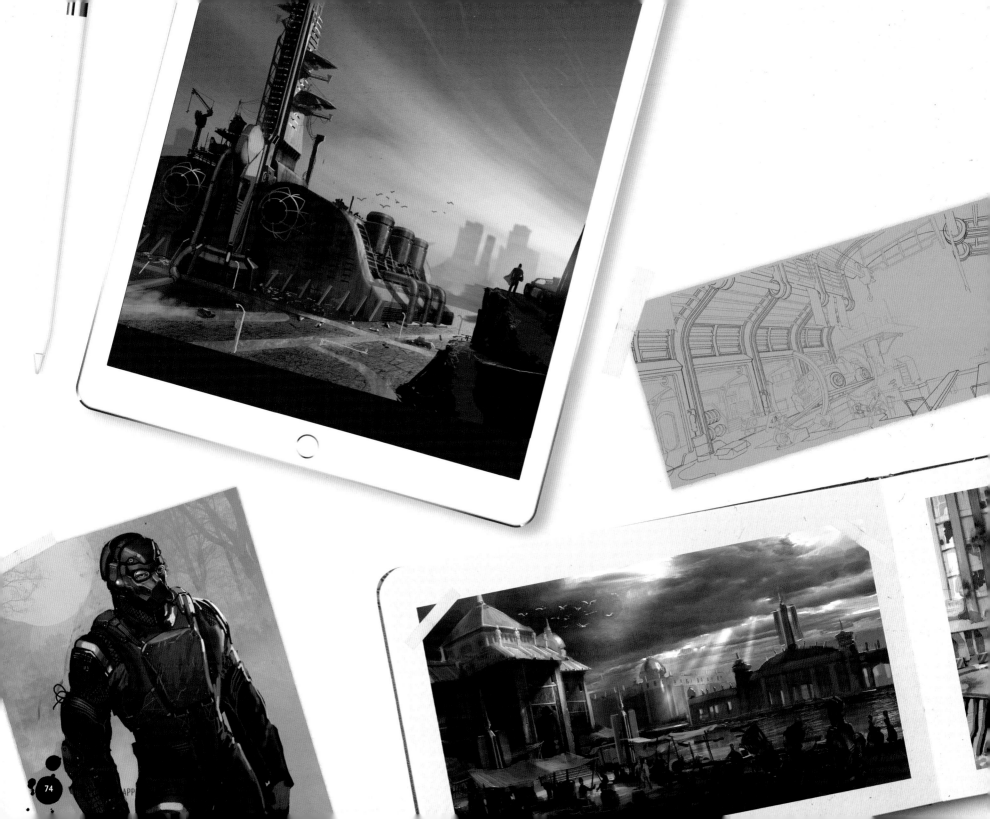

WHAT HAPPENS NEXT?

After you have submitted an art test, the following days can be full of anxiety. Time seems to drag: minutes will feel like hours, and days seem like weeks. Once you have made sure that the art director has actually received the test, use every ounce of restraint not to pester them about the results.

IF YOU DID WELL

If the art director likes your art test, someone from the human resources department will get in contact with you within a few days. He or she will usually ask for your availability for an in-person interview.

IF YOU DID POORLY

If a week or two has gone by and you haven't heard a peep out of the studio, you probably haven't gotten the job. However, to be safe, check back with your point of contact. Ask if you are still being considered for the position, and if there is anything else that he or she requires from you.

GET FEEDBACK

If your art test was rejected, politely ask why. Speak to the art director to get feedback on your image and your portfolio. Ask what you could have done to improve them both. Take note of this information—hopefully the lessons you have learned on this test will improve your chances on the next one.

CHAPTER 06 : THE JOB INTERVIEW

- CHAPTER 06 -

THE JOB INTERVIEW

WHAT TO EXPECT DURING IN-PERSON INTERVIEWS

In-person interviews are the final stretch in the job-hunting process. Studios will typically fly you out to the studio, coach class, to meet the art director and the team, and to check out the facilities. Depending on your schedule, they may also put you up in a hotel and provide a rental car or taxi service to get around.

Such interviews usually last half a day or so. You will probably arrive at the studio in the morning, where you will meet the HR representative or hiring manager. He or she will usually show you around some of the facilities, then introduce you to the art director. The art director will give you the rest of the tour, introducing you to the team as you go. When that is done, you will probably be brought into a room where the interview will officially begin. Team members usually arrive in groups to ask you a few questions, and then will hand you over to the next group to ask their questions.

Lunch will either be provided on-site, or team members will take you out to a restaurant. After lunch there may be more questions. The day ends by meeting up with the HR representative again. He or she will ask you for your salary requirements, start date, and other sensitive information. He or she will also go over the next steps with you and schedule a follow-up conversation to discuss a job offer. Your flight back home may be scheduled for that evening or the following day.

While you are in town, the studio may pair you with a real estate agent who will take you to look at houses or apartments. Personally, I've always found this a bit awkward, since you are looking for a place to live without knowing whether you have the job, or how much you will be paid. However, if you can't find anywhere you like, the studio may fly you back later to continue your search.

WHAT TO WEAR DURING THE INTERVIEW

Because the gaming industry does not have a dress code, you can dress relatively casually for interviews. My recommendation, for men, is to wear a button-down collared shirt with trousers or nice jeans and comfortable shoes (not flip-flops). For women, I suggest wearing a suitable top (one that is not too revealing) and trousers or a skirt to match. The goal is to look presentable but not too formal.

Wearing a suit and tie is probably overkill, and will certainly make you stand out in the studio, unless you're applying for a senior or management position, in which case you may need to look the part. The studio is investing in you as an entire package, and your appearance is part of that package.

WHAT TO BRING TO THE INTERVIEW

Bring several copies of your résumé, a hard copy of your portfolio, a small notepad, and a pen. If you have any additional examples of your work that the studio may not have seen, you can bring those along as well. Sketchbooks are always fun to see, but never required at interviews. I only recommend showing them if you have solid pieces in there.

It also makes sense to bring the phone numbers and contact information of both the art director and the HR representative in case something comes up before, or after, the interview, and you need to get hold of them quickly.

AN IN-PERSON INTERVIEW IS YOURS TO LOSE

Due to the cost of flying a candidate in for interview and lodging them while they are there—not to mention interrupting the game's development so that team members can interview you—studios are very selective about who they bring in. The fact that you have got an in-person interview means that you are a final candidate. If you play your cards right during the interview, the job is effectively yours to turn down. Because such interviews are usually just a formality, there are only a few things that can jeopardize your job. Here are some of the most common ones.

BAD PERSONALITY

Nobody likes working with unpleasant people. Even if you are the most brilliant concept artist the world has ever seen, if you are opinionated, egotistical, or talk down to people, few studios will want to hire you. You need to have a personality that people like.

AGGRIEVED EX-COWORKERS

If you have offended somebody at your last job, and that person works at the studio where you are applying, he or she may be in a position to block your admittance.

UNREALISTIC SALARY REQUIREMENTS

If you and the studio can't come to an agreement over pay, or if the studio has a candidate who will do the same job for less, you may have to be prepared to walk away from the job. We'll talk more about how to negotiate your salary in Chapter 07.

WHAT TO EXPECT DURING OVER-THE-PHONE INTERVIEWS

Sometimes the interview is simply handled over the phone. It is usually initiated by the HR representative, who sets up a meeting between you and the art director. The interview may be as brief as a few minutes, or as long as a few hours, during which you will find yourself asked a barrage of questions, possibly even by several people at the studio.

BEFORE THE INTERVIEW

:: Make sure you schedule the meeting during your largest, uninterrupted block of time.

:: Make sure your cell phone is charged—have the charger on hand just in case.

:: Make sure that the area you have chosen gets good reception, is not too loud, and has somewhere to sit down.

:: Have paper and a pen on hand so that you can take notes.

:: Prepare some questions to ask your interviewer. We'll discuss this later in the chapter.

When possible, always ask for an in-person interview. Interviewing over the phone means that you don't get to check out the studio and its facilities, meet the team, nor see the game.

DURING THE INTERVIEW

:: Consider using a hands-free headset if you have one: whatever lets you talk most comfortably.

:: Don't chew gum—it comes over as unprofessional, and you want to be heard as clearly as possible.

INTERVIEWING WHILE AT WORK

If you have to take the call during work hours, it is best to leave the premises, so that you can speak freely. If you can't leave, try to find an empty office or unused private space. Decide where you want to take the call ahead of time, so that you don't have to hunt around later.

On the day of the call, head to your predetermined location a few minutes early and wait for the call. Set an alarm to remind you if needed. Being caught off-guard and having to rush there will leave you winded and flustered. It's a terrible way to begin an important conversation.

INTERVIEW TIPS

Acing the interview not only improves your chances of getting the job but puts you in a stronger position when the time comes to negotiate your salary. Here are some things you can do to help your interviews go smoothly.

REMEMBER NAMES

Make an effort to remember the names of your interviewers. If you have a hard time remembering, write down the names when you get a private moment.

BE POSITIVE

Remain positive, energetic, and upbeat during the interview. During in-person interviews, be aware of your body language and posture. These things can say a lot about you.

BE HONEST

Answer any questions as honestly as possible. If you don't have an answer, just say so and ask the interviewer to explain the issue to you. This gives you the chance to show your humility, while they get to show off what they know.

ACT LIKE YOU BELONG

Even if you are, never act like you are fresh out of school, or beneath the interviewer in some way. While you should remain humble and modest, in the back of your mind, always remember that you are an equal. Your aim is to convey that you are a professional, not an amateur. Unless instructed otherwise, you can call people by their first names. You don't have to call them "Mister" or "Miss".

BE DIPLOMATIC ABOUT PREVIOUS JOBS

Never bad-mouth your previous company or your former coworkers. Studios will begin to wonder if this is an indication of the kind of loyalty they can expect from you. If you left a studio on bad terms, draft a simple explanation in advance, and then leave it at that—stay neutral when possible. Even if you feel you were in the right, if you go into details, you may unintentionally sour the interviewer's opinion of you.

PICK YOUR BATTLES

In some cases, creative directors may have specific things that turn them off, like comics or anime. If you hear that they hate something that you love, it's best not to get into a spirited discussion about it. Instead, ask them what types of things they're into and find points in common there.

> During the interview, you will be judged on how well you can communicate your ideas to the team. If you are not used to talking to crowds of people at a time, it can be a good idea to practice your answers ahead of time in the mirror, or use note cards to address possible talking points. Practice will make you more comfortable and will lower your anxiety levels and improve performance.

WATCH FOR REPEATED QUESTIONS

If different sets of interviewers keep asking you the same question, this usually indicates an item of concern. It isn't necessarily about you—it could be the issue that created the vacancy in the first place.

ENGAGE YOUR INTERVIEWERS

Get a feel for each person that interviews you, and try to respond to them on their own level. You will know the interview is going well if, by the end, you are all laughing and joking like old buddies.

ASK QUESTIONS BACK

Your goal is to make the interview feel more like a conversation than a one-sided drilling for information, so be prepared to ask questions of your own. Doing so also shows the studio that you are interested in its work. Your questions don't all have to be work-related—some can be personal as well. Here are some possible questions to ask.

:: How long has the game been in development?
:: Has it gone through any reboots or overhauls?
:: Why is this position open? Is it because someone left, or because the studio is expanding, or is this an opportunity hire?
:: How well is the company managing its other intellectual properties? Are they being received well in the marketplace?
:: Can you explain your pipeline, and how I would fit into it? Who would I be working with directly?
:: What has your experience been like on this project?
:: How happy are you with the way management has handled the project so far?

Pay close attention to your interviewers' nonverbal mannerisms while they answer your questions. If they look uncomfortable, it may indicate that things aren't going too well at the studio. If they scoff, smirk, or chuckle to themselves when asked about questions about the management or the pipeline, the chances are that the project is in trouble. If, however, your interviewers are all upbeat, energetic, and generally positive, you can take this as a good sign.

THINGS TO CONSIDER AFTER THE INTERVIEW

The interview process works both ways. The studio may be checking that you are a good fit for its needs, but you should also be checking that the studio is a good fit for your own. During your visit, take the opportunity to gather as much information as you can, and to observe your potential coworkers. Here are the things you should be concerned about, in order of importance.

IS THE PROJECT GOING WELL?

First and foremost, are you excited for the project? Is it something you want to work on for the next few years of your life? Based on the number of development changes, setbacks, and/or reboots, how likely is it that this project will ship, and how good is it shaping up to be?

ARE THE EMPLOYEES SATISFIED?

Observe employees' attitudes and outlook towards the project—are they stretched thin? Overworked? Burned-out? Or do they generally enjoy coming to work each day? How invested do the staff seem in the project? Are they distant and removed, or intimate with the details? Finally, what is the age of artists in the studio? Are they mainly college students, graduates and twenty-somethings? Or is the studio composed of more seasoned veterans?

HOW IS THE STUDIO MANAGED?

How organized does the studio seem to be? Is there a clear chain of command between management and employees? Are the management's expectation transparent? How happily do you think you could work in such an environment?

DO YOU LIKE THE WORKING CULTURE?

How well does your personality fit with the other artists in the studio? Do you have things in common with them? Take note of their working environment. Are they are working quietly in cubicles, with headphones on? That indicates a culture of isolation. Or are the tables grouped together in the middle of the room? That may signal a collaborative effort. Are people happy there? Or are they mindless drones?

ARE YOU HAPPY TO RELOCATE TO THE AREA?

Will you be happy living in the city or country where the studio is located? What kind of events, nightlife, and activities are there in the area? If you have a significant other, will he or she be happy living there? Are there opportunities for gainful employment in his or her own field?

SPOT THE RED FLAGS!

Walking into a video game studio (especially if it is your first) can be as magical as setting foot inside Willy Wonka's chocolate factory, but don't let the "wow" factor blind you to potential problems. Keep in mind that if a game you work on is canceled, you won't have anything to show for that work. That can translate to a dead spot of several years in your portfolio.

There will always be unforeseen issues that can lead to a title's downfall, but if you are aware of the common causes of disaster, you may spot them ahead of time. Here are a few "red flags" that may indicate that things are going wrong at a studio.

TOO MANY CLONED TITLES

Every video game tends to "borrow" ideas and mechanics from others on the market. (It's the industry we work in, sorry.) But you should be alarmed if a high percentage of a game's content is a rehash of something you have already seen. Be especially alarmed if the studio describes its own titles as one game mashed together with another: "It's like Call of Duty meets Mario ..."

START-UP STUDIOS

Be wary of joining a start-up. By definition, they are unproven, and unless they have solid management or experience making games, the chances are that you will end up with a headache.

SMALL STUDIOS THAT BULK UP QUICKLY

Having multiple projects in development can be either a blessing or a curse. If the team is large enough to accommodate multiple projects, and one fails, the studio can fall back on the second project, ensuring its continued survival. If this happens, the worst-case scenario is that some jobs will overlap, which can result in layoffs, but fewer than if the studio had folded completely.

But if a studio is small, stretching the team across multiple projects can place stress on the entire company, which threatens all of the projects in development. To combat this, a studio may take on more staff—but often, when a studio grows too quickly without the infrastructure to support it, it begins to buckle under its own weight. This can lead to all kinds of disasters down the road, like layoffs, or even complete closure.

LIQUID DEVELOPMENT

To management, the term "liquid development" means that a studio can adapt to anything on the fly. It is especially common among third-party developers who have to work with publishers to produce their games. Since the publisher tends to have demands that the developer must follow, being "liquid" means that it can adapt to change requests and still hit deadlines.

But to content creators, the term can be code for "operating without any real plan". This is a nightmare. Artists can expect to have to design, and then redesign, and then re-redesign the same game asset until it gets approved. Such do-overs indicate a lack of overall vision for a project, and can be a determining factor in the decision to reboot a title from scratch. This usually delays its shipping date, and the added hours of stress and aggravation are the fastest way to burn out your creativity.

During interviews, if the higher-ups (like art directors or producers) proudly refer to their development process as being "liquid" or "fluid", you should cautiously investigate further. Ask them to explain what the term means to the studio, and how it affects the development pipeline. Later, try to ask the same questions of the content creators you meet during your interview, and see what they have to say. Pay close attention to their nonverbal cues.

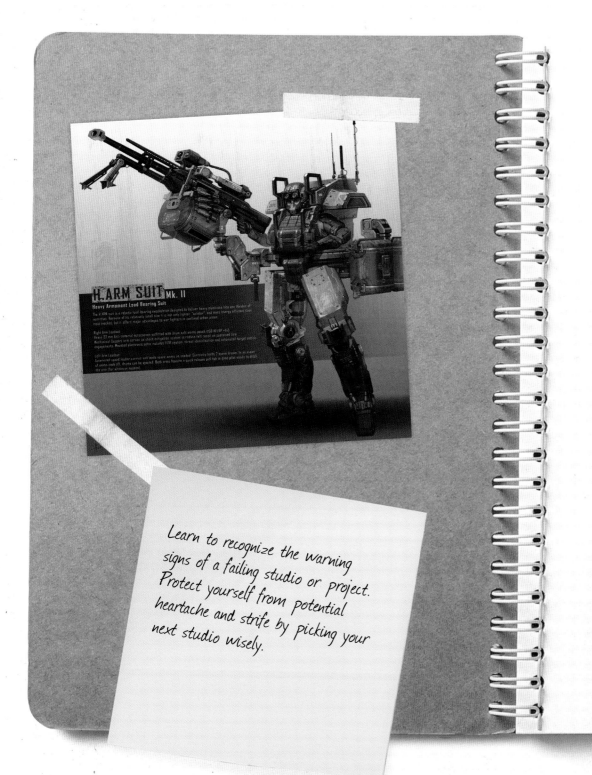

H.ARM SUIT Mk. II
Heavy Armament Load Bearing Suit

Learn to recognize the warning signs of a failing studio or project. Protect yourself from potential heartache and strife by picking your next studio wisely.

A Personal Story:

I flew down to a studio for an in-person interview. When I got there, I instantly got weird vibes from the place. Everyone was in isolation; no one seemed to be happy. The project seemed cool enough, but management had a weird system of doing things that seemed backwards to me.

When I met with the concept art team, they all seemed disgruntled. They were quiet, stared down at the floor, and none seemed interested in the discussion. They did not try to sell the game or the project to me at all. I took this as a bad sign and avoided the studio. A friend of mine took the job instead and was happy with it … for a while. Six months later, the project was canceled and the studio shut down.

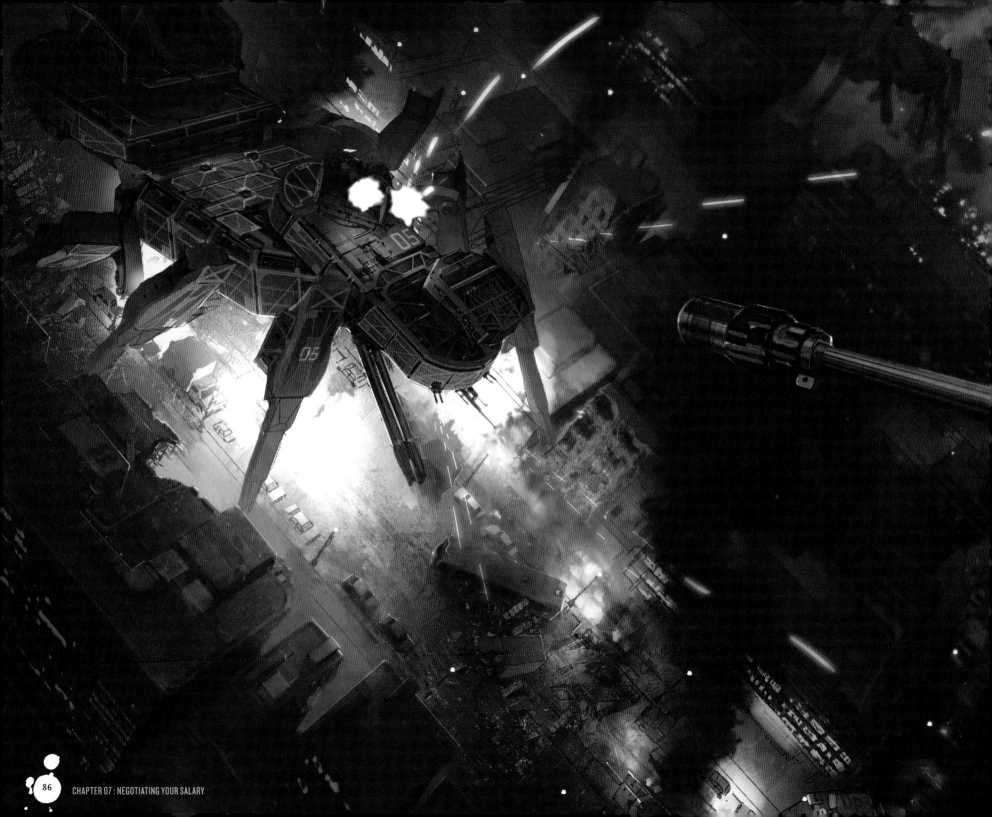

- CHAPTER 07 -

NEGOTIATING YOUR SALARY

HOW TO DETERMINE YOUR BASE SALARY NEEDS

Your salary will depend on your experience in the industry, your level of education, your negotiating skills—and ultimately, what you are prepared to accept. But your outgoings aren't so flexible. Your goal should be for your job to sustain your desired quality of life. That means calculating your base salary needs.

FIGURE OUT YOUR MINIMUM MONTHLY COSTS

Coming up with a figure is more than just guesswork or accepting the studio's first offer. You have to consider your own expenses. Tally up your expected monthly outgoings if you were to accept a job at the studio. That includes the cost of renting or owning an apartment in that area, transport to and from work, student loans, utility bills, and so on. Take that monthly total, multiply it by 12, and that figure will be the absolute bare minimum you will need to clear after taxes to sustain your quality of life.

ALLOW FOR TAXES

Remember to allow for tax! Since almost a third of your salary goes to the government and your benefits package, if your annual expenses total $32,400, you will need to add a further $10,800 to that figure. This means that, in order to sustain your minimum quality of life, you cannot afford to get paid anything less than $43,200 per year.

A BASE SALARY ISN'T A GREAT SALARY

Also remember that if you only cover your minimum expenses, there won't be any money left over to account for life's unexpected emergencies, save for a rainy day, hang out with friends—or even just pay for your Xbox Live service. If starting salaries are around $46,000 per year in the area where the studio is based, you can instantly see that you won't have money to do much else.

HERE IS AN EXAMPLE

Based on a monthly total

Rent	$1,300
Utilities	$300
Student loans	$400
Phone/Internet/cable	$200
Transportation	$200
Food/groceries	$300

Monthly total amounts to:	$2,700
x 12 months/year: $2700 x 12	
Minimum annual salary required	$32,400

RATES AND LONG-TERM PLANNING:

HOW DO YOU DETERMINE YOUR WORTH?

Your worth has nothing to do with money. Don't let the external evaluation of your earning potential affect your internal sense of worth. It's essential for staying emotionally and spiritually healthy. Worth and earning potential are different things. ...and there are many different factors that affect your earning potential. Here are a few questions to consider when trying to estimate your own earning potential:

1.) Consider my response to the fourth question on page 25. Does the financial value you offer align with the financial values of the studio or client with whom you want to work? If not, then your earning potential will decrease. Scarcity drives value. If the studio is just looking for the cheapest artist available, then you can assume that just about anybody who knows the relevant software can do the job. There's not even a financial incentive (let alone value) for the studio to pay you well. In addition to being underpaid and under-appreciated, you'll be bored.

2.) Consider those who offer the same kind of value you do. We'll call them your "competition." Are most of them working professionally right now or are they all currently looking for work? If the "micro-economy" within your field of specialization is healthy then many of your competitors will be gainfully employed elsewhere. Your earning potential will probably increase because the studio has less options.

3.) It's not a successful business agreement if either party feels cheated or only one party benefits. If the studio or client with whom you're working is trying to trick you, then cling to your dignity and exit gracefully. If you and the client can't find a win-win agreement, then walk away.

...WITHOUT LEAVING 'MONEY ON THE TABLE'?

1.) Do great work, be great to work with and tell your story well. Let these three values guide your professional life and your earning potential will increase. Just this past weekend I met with a well-known fantasy art director. She expressed something I hear all the time from art directors and recruiters in every part of the entertainment industry: 'We're having a hard time finding illustrators to work on a new project at our company. Everyone who is good and dependable is too busy. Sure, there are a million illustrators out there but right now we can't seem to find a great illustrator who is also professionally consistent.'

There's more room at the top.

2.) Ask for the salary for which you know you're qualified and that you know the industry can sustain. Generally speaking, a Visual Development artist in animation will probably make more money in a single day than a work-for-hire comic artist but the required skill sets are very different.

"After years of being a professional artist, what personal advice can you offer up-and-coming artists regarding their journey ahead?" Obviously, craft is essential. ...but when working with a studio or independent client your main job is not being the best artist. Your main job is making your art director's job as easy as possible.

THE SALARY NEGOTIATION PROCESS

Assuming that things have gone well in your interview, at some point in the day, you will meet with the HR representative to discuss your potential salary. By now, you are in the home stretch, but salary negotiations are a delicate thing, and your career is on the line. Here's how to prepare for the meeting

WHAT THE STUDIO WILL DO

After your interview, the people you just met will get together and discuss the potential value you bring to the project. They will be considering the things they liked and disliked about you, your personality, and any red flags they spotted during the interview. They will also be comparing you to other candidates they interviewed to see who is the better fit for the team.

Based on the team's recommendation, the hiring manager or HR representative will meet with the higher-ups to discuss the offer they want to make. This meeting will determine whether the studio offers you a lucrative salary in an attempt to snatch you up right away, or whether it tries to lowball you. It will already have a figure budgeted for the position but, as a business, will be trying to retain your services at the lowest possible cost.

WHAT YOU SHOULD DO

Before the interview, you will need to arm yourself with some basic information. First, you should have calculated your minimum salary requirements, based on the cost of living in the city or state where the studio is located. We looked at how to do this earlier in the chapter.

You should also look up the average salary for jobs similar to the one you have applied for. Salary surveys are a great place to find this kind of information: you can find a list of them in Chapter 10. If you feel that you would bring additional qualities to the role, research the salaries of artists with comparable skills and levels of industry experience.

Lastly, research the company itself to get a feel for its economic strength. Larger companies may have more money to play with than smaller ones.

HOW TO NEGOTIATE

Negotiation tactics vary from studio to studio. Some studios will simply discuss your salary requirements during your interview, then follow up with you later; others will have the person who is authorized to make the final call there on the day. In case you have to negotiate on the spot, here are some things to bear in mind.

NEGOTIATE WHEN YOU ARE STRONGEST

Try to avoid discussing specific figures until after you've secured the position. (That is, after the studio has made you an offer.) It's much easier to negotiate once you know that the company wants you on board.

LET EMPLOYERS MAKE THE FIRST OFFER

Never make the first move. If the studio asks you what salary you expect, ask them what they have budgeted for this position. The hope here is that their figure will be higher than yours, preventing you from selling yourself short.

BE FLEXIBLE

When discussing your salary requirements, don't provide a single figure. Having a fixed figure in mind is dangerous: if it doesn't match what the studio is willing to pay, it leaves no room for negotiation. Always say that the sum is "negotiable", or that it "ranges between X and Z, depending on benefits".

REMAIN CALM

During negotiations, don't take anything personally or get emotional—it's business. If your salary demands get shot down, don't show disappointment. Remain professional.

AVOID ACCEPTING OR NEGOTIATING AN OFFER ON THE SPOT

If possible, avoid committing to an offer during the meeting. When you receive the offer, thank the person making it, restate your desire to work for the studio, then tell them that you need time to think it over. This will give you time to evaluate the entire compensation package to see what you are really getting.

Negotiation Tips :

:: Whatever your target salary is, state the figure with unflinching confidence. Never pose it as a question, or let the inflection at the end of your sentence turn it into one: "I would like 50K?" The uncertainty in your voice will indicate that not even you think you should be getting that figure.

:: Make sure that you've taken the cost of living in the city where the studio is based into account, not your own current cost of living. Getting paid $50,000 per year in Texas is not the same as being paid $50,000 per year in Los Angeles.

:: When it comes to your base salary needs, stick to your guns. If you determine that $46,000 per year is the minimum you need to get by, and the studio offers you $45,000, walk away or make a counteroffer.

"WHAT WAS THE LAST SALARY YOU RECEIVED?"

Over the course of your career, you may be asked this sensitive question by interviewers (usually HR representatives or recruiters). Your answer can dramatically affect the salary you are offered: too high, and you price yourself out of the market; too low, and you cap your maximum potential income.

On principle, try to work around the question by providing your target salary, rather than your salary history. You can attribute your unwillingness to divulge the information to your previous employer's policies, saying something like: "Company X was adamant about us keeping salary figures private. Likewise, as I'm sure you can appreciate, I wouldn't share my salary information with anyone else at this company if I were working here." While this conversation can get very uncomfortable, politely and respectfully evading the question remains the best option open to you.

Sometimes, however, you may be cornered by an interviewer who won't let the subject go. If he or she presses the matter, consider these possible responses.

IF YOU WERE SLIGHTLY UNDERPAID AT YOUR LAST JOB

Answer truthfully, but explain why you believe that you are now worth more: perhaps because you have learned a new skill or program, or have received an extra professional qualification. Demonstrating that your value to an employer has increased will help validate your current asking salary.

IF YOU WERE GROSSLY UNDERPAID AT YOUR LAST JOB

Try not to answer the question at all. Doing so will make it seem like you are willing to work for less than your worth. Instead, say something like: "I took a job at my last studio at a reduced salary because I wanted to work on Project X." This makes you sound almost noble, and puts the interviewer on notice that you won't be taking a pay cut again.

IF YOU WERE PAID FAIRLY AT YOUR LAST JOB

Answer truthfully, then describe all of your benefits, paid overtime, vacation days, and bonuses. You don't have to get too specific, but it's worth mentioning any incentive that significantly adds to your salary package, like day care. Don't exaggerate: the studio can easily check your answer by going back to your previous employer.

IF YOU WERE PAID WELL AT YOUR LAST JOB

Answer truthfully, but offer a personal explanation as to why you want to work on this project, hoping to connect with the interviewer on an emotional level. Having been paid more than the market rate at your previous studio is a double-edged sword: on one hand, it shows that another company valued your talents; on the other, it may make the interviewer assume that their studio can't afford you.

Respect is a two-way street. If you think the company hiring you is doing you a favor, you don't have a high enough opinion of yourself. And you can't successfully job hunt in that mental state.

If you sense that an employer is determined to obtain your services at the lowest possible cost, ask yourself whether you really want to work for them. If not, be prepared to walk away.

COUNTEROFFERS

After the interview is over, you fly back home and will have to play the waiting game until you receive the offer letter. This is usually e-mailed to you for approval, then mailed to your home address for signing. Until you have returned the signed copy to the studio, your new salary is not guaranteed. Sometimes the offer you get back isn't the offer you expected. This can be due to a number of factors. Perhaps the HR person wants to look good to their bosses by negotiating you down. Perhaps there is another, equally talented artist that the studio is considering. Or perhaps the budget has shifted. Regardless of the reasons, when this happens, don't take it as a personal insult: again, it's just business. If you determine that the new offer is below the market rate for the job, or that it won't cover your base salary needs, you have nothing to lose by respectfully asking the company for more money. Here's how the process works.

HOW TO MAKE A COUNTEROFFER

First, thank the employer for their job offer, and state that you are looking forward to working with the studio. Lead into the counteroffer with the assurance that the only thing stopping you from joining the team is a mutually agreeable salary.

Expecting to be negotiated down, propose a salary that is a few thousand dollars higher than the figure you actually want. In some cases, your request will have to be approved through a chain of command; in others, the hiring manager will have the authority to make the final decision. If you are lucky, the studio will come back with a new offer close to the figure you desire.

A WORKED EXAMPLE

Let's suppose you have just applied to a large studio with deep pockets, have aced the art test, and during the interview the team displays all the signs that they are super enthusiastic to have you on board. All signs point to smooth sailing ahead – until you get their offer.

If your research tells you that the average starting salary for the job you are applying for is $65,000 per year, but the studio is only offering $50,000, then you know the offer is low. After crunching some numbers, you determine your bare minimum expenses while working at the studio will be $41,000 per year. A counteroffer is definitely warranted. Explain to them that you have investigated similar positions and were expecting a higher offer. Complement your research with an explanation of what you

want, why you want it, and how you will benefit their company. (You have to prove to them that there is value behind the salary increase).

So, for example you might say: I'd like to remind you that one of my strengths is that I am proficient in both 2d and 3d programs, so I can take a task from concept all the way through to in-game asset creation. This will speed up your turnaround times and streamline your pipeline immensely". Then ask them if they are willing to extend a higher figure, closer to $65,000 per year.

With a bit of luck, you may end up somewhere around $60,000 per year. That's still close to the industry average, and $10,000 more than you would have gotten had you not negotiated.

KNOW WHEN TO STOP

If you over-negotiate, you risk losing the employer's good will. Playing tug-of-war over your salary can be extremely stressful, and should only be done if several thousand dollars are at stake. If your would-be employer has already raised its offer, haggling over a minuscule amount of money can cause the studio to withdraw the offer entirely and turn to another candidate with fewer demands.

IF ALL ELSE FAILS

If the studio's final offer is lower than the figure you want, you have two choices: to accept the offer currently on the table, knowing that you are being underpaid, or to turn it down entirely. Don't make a counteroffer unless you are actually prepared to walk away.

COUNTEROFFER TIPS

:: Don't rush to make a counteroffer. First determine if what the studio has offered you is fair, and whether you are comfortable with it. This is why it is always a good idea to take the offer home, crunch some numbers, and think things over.

:: When drafting a counteroffer, don't state personal reasons for needing more money. This is very unprofessional, and can make you look desperate, which will weaken your negotiating position.

:: Always reiterate your excitement about the position and how much you want to work for the studio. Then state why you believe yourself to be worth a higher salary, or point out that at the offered figure, you will be unable to maintain your current quality of life. This will reassure your employer that the only thing stopping you from taking the job is the money.

:: If you are worried about your resolve, ask a friend to play devil's advocate and practice salary negotiations with you. You want your arguments to come naturally so that you feel comfortable enough to be able to go back and forth confidently when the real negotiations start.

A Personal Story :

At my very first video game studio, I was initially offered a base salary of around $40,000 per year. The hiring manager said that the offer was pretty good for a young, unproven artist right out of college. And she might have been right, except that I knew that I was not an unproven kid fresh out of school.

To counter her argument, I used my master's degree as evidence of my artistic merit, reminded her that I had had years of industry experience working for some big-name clients while I was still in school, and then provided her with professional references. These arguments proved that I wasn't a newbie but a young professional qualified for the position, and merited a higher base salary. My counteroffer proved successful, and I was offered an additional $10,000 per year.

WHY ACCEPT A LOWER SALARY?

As artists, what ultimately makes us happy is not how much money we make: it's whether our work fulfills us. Here are some instances in which you might be inclined to take a job at a lower-paying studio over one that offers a higher salary. It isn't an exhaustive list; just a few examples.

FINDING A MENTOR

If one of the senior staff at the studio is willing to mentor you, this can be worth its weight in gold, particularly if you are fresh out of college. A mentor will aid you, challenge you, and force you to grow artistically. Time spent with one can shape your entire career.

BETTER WORK CULTURE

During the interview, you might notice that the studio has a relaxed work environment. This could be a welcome change of pace in your life, enabling you to spend more time with family and friends. Or perhaps, it is filled with people whom you instantly bonded with during the interview. Nurturing those connections can turn them into lifelong friendships.

WORK YOU LOVE

The studio may be working on a project that you really want to be a part of. Or perhaps the work that you will be doing there will be particularly satisfying, challenging, or meaningful.

NO NEED TO RELOCATE

Working for a studio in the city in which you currently live means that you can stay closer to family and friends, and that your partner won't have to uproot his or her life to be with you.

BETTER BENEFITS

Some studios may make up for poor salaries with excellent benefits. If you have, or are prone to, health issues, or are expecting a child, a studio that offers fully covered medical, dental, and eye insurance plans may be more attractive.

GREATER ARTISTIC FREEDOM

Understanding that a happy artist is a productive artist, some studios may allow you to develop your own personal side projects outside of work without penalty. You may be allowed to take on freelance jobs, create your own intellectual property, or publish a book.

Recruitment timescales vary dramatically from studio to studio. The entire process—from submitting your portfolio to receiving the final letter of offer—can take as little as two weeks, or as long as several months.

RAISING YOUR GAME

When you first enter the workforce, you are the low person on the totem pole—meaning that you get the jobs no one else wants. However, as you gain experience in the industry, ship a few titles, and get better at your craft, roles for which you were previously unqualified become attainable goals. This process takes time, so usually six or more years of industry experience are required before you reach a position of seniority. Here are six things you need to do before you can move to a senior role.

:: PRODUCE A HIGH QUALITY OF WORK

You have developed a proven production process that consistently enables you to create the highest quality and quantity of artwork in the shortest time possible. Art directors know your style and have a clear idea of what they can expect from you.

:: MEET ALL OF YOUR DEADLINES

You are able to "time-box" (schedule) your tasks accurately, and can negotiate your own work timetable with your art director.

:: COMMMUNICATE EFFECTIVELY

You are able to convey your ideas effectively to both the creatives and non-creatives on your team, in your artwork, in meetings, and in written communications. This ensures that the right designs get seen, approved, and built.

:: ACT LIKE SENIOR TALENT

You are a true professional, acting and speaking in an appropriate manner. You understand what the job really involves, and are willing to put in the hours needed to get the work done. If you ever have an issue with the project management, you go through the proper channels to voice your concerns. You also know how to pick and choose your battles at the office.

:: HANDLE MORE RESPONSIBILITY

You are able to work without anyone holding your hand, becoming the "go-to" person for a particular task. As you prove your talents, you may be asked to train newer artists or manage established ones. You may even be put in charge of collaborating with other teams within the studio.

:: MAKE YOUR BOSS LOOK GOOD

You take the initiative on jobs and provide solutions to problems that haven't even come up yet. These leadership qualities make your art director's job easier. As a result, he or she begins to lean on you to get things done. Higher-ups become be more inclined to trust your judgment, and look to you for answers.

> "Time-boxing" is the process of assessing how long it will take you to complete an assignment and relaying that estimate to your art director. He or she will use the information you provide to draw up a project schedule: not just for you, but for the rest of the team. Failing to hit your goals will affect the entire project, so it is important for everyone concerned that your estimates are accurate.

NEGOTIATING PAY RISES

As you grow more senior, you should be able to negotiate a pay rise. The fastest way to do this is to move from studio to studio. If you were underpaid at your last job, starting a new one is a good opportunity to get things back on track. Here are some arguments you can use to negotiate an increase in salary.

IMPROVED SKILL SET

If your abilities as an artist have grown—that is, you have gained speed and proficiency in producing your work, expanded your skill set, or become familiar with new programs within the production pipeline—then so has your value as a team member.

ADDITIONAL RESPONSIBILITIES

If you have taken on more responsibility at work (for example, expanding your role from environment artist to working on characters and props, or helping to manage other people), you have also increased your value to future employers.

ACCOLADES

Every time you receive new professional qualifications, awards, or any form of public recognition, you add to the value of your personal brand.

COST OF LIVING ADJUSTMENTS

It is not uncommon to increase your asking salary by ten to fifteen percent just to cover inflation and cost of living increases. Because the cost of living may vary between states (or between countries), you need to ensure that your new salary is sufficient to maintain the quality of life to which you are accustomed.

MOVING TO A LARGER COMPANY

It's also worth factoring in the size of the company to which you are applying. At video game studios that make high-grossing games and have larger operating budgets, you may be able to get away with asking for a larger salary increase.

MULTIPLE JOB OFFERS

When applying for several jobs at once, you may receive multiple job offers from competing companies. You are well within your rights to ask if one company can match or beat another company's offer.

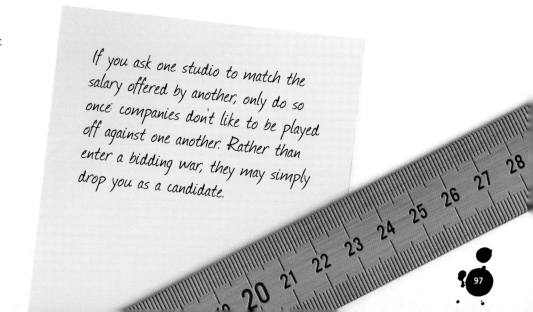

If you ask one studio to match the salary offered by another, only do so once: companies don't like to be played off against one another. Rather than enter a bidding war, they may simply drop you as a candidate.

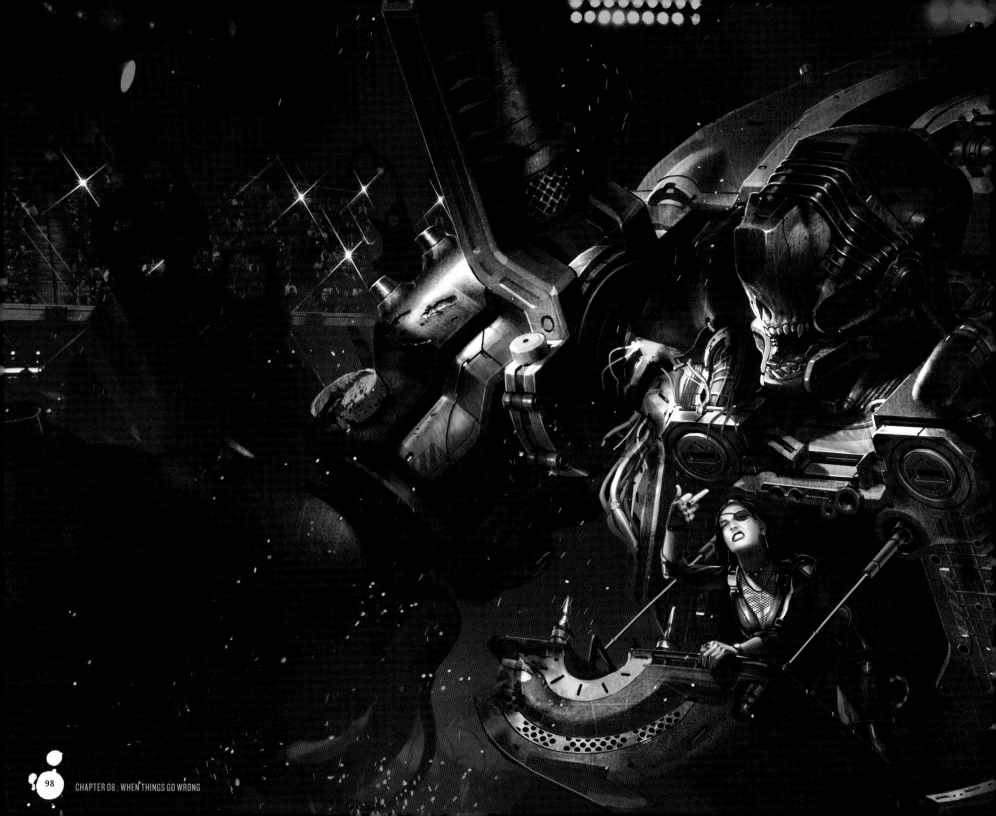

CHAPTER 08 : WHEN THINGS GO WRONG

- CHAPTER 08-

WHEN THINGS GO WRONG

SPOTTING THE WARNING SIGNS

Sadly, work doesn't always go smoothly, even at the best studios. The problem may be something specific to your job, or something systemic to the studio itself. Below, you can find a list of common warning signs that things are going wrong. If several of them apply to you, it's time to start thinking about what you can do about it.

PERSONAL ISSUES:

:: You feel that you are being underpaid.

:: The hours that you are working are affecting your personal life.

:: Your creative needs are no longer being met by your job.

:: You dislike the type of work you're doing.

:: The thrill of the challenge is gone, and you are coasting simply to collect a paycheck.

:: Work culture has become toxic.

STUDIO ISSUES:

:: The publisher has started making demands that are way outside the project's initial scope.

:: Key talent on the project leaves.

:: The project is close to wrapping up, but there is no new project lined up on the horizon.

:: After shipping, the project has been poorly reviewed, making a sequel unlikely.

:: Paychecks are being delayed or bonuses are being pushed back.

SO WHAT'S THE SOLUTION?

No one at work is going to fight for your interests better than you. Therefore, if you are unhappy about something on the job, the onus is on you to address it. This can be done through a simple conversation with your art director or manager, or it may require more drastic measures. In the rest of this chapter, we'll look at the options available to you. First, we'll explore four fictitious—but representative—examples of problems you might face, and how you could negotiate to resolve them. You can adapt these strategies to your own situation. After that, we'll explore the options of last resort: threatening to leave the studio, and actually quitting.

IF YOU ARE UNDERPAID

If you have remained at a studio for several years, your salary may not have increased in line with the market. Below, we'll set out an typical situation of this type—the details are made up, but you can modify them to match your own job—along with the information you would need to support your case, and the way in which you could present your argument to the management.

THE PROBLEM

You got your job right out of college and are receiving a low salary. Years later, with a shipped title under your belt, you are still making about the same money, and despite bringing this fact up during your reviews, no attempts have been made to properly compensate you.

THE INFORMATION YOU NEED TO COLLECT

:: Written evidence of times when you have gone above and beyond your job description (e-mails, instant messages, and so on).

:: Any testimonials you have received from your art director or other senior staff.

:: The industry-standard salary for a job of this type.

YOUR ARGUMENT

"Although I graduated years ago, the salary I am currently making is little better than the one I got right out of college. I have a shipped title under my belt, and several years of experience now. Time after time I have gone above and beyond my job duties, and have stepped up when I have been called upon. I have improved my skills in areas X and Y, and have produced and contributed more usable art to the game than other artists. According to the salary surveys I have looked at, someone in my position should be earning $20,000 per year more, and I am looking for a pay rise to reflect this."

IF YOU ARE OVERWORKED

If you are being assigned a disproportionate number of tasks, or faced with impossible deadlines, it's time to take action. Again, we'll explore a case study illustrating this situation, along the information you would need to collect in order to negotiate either a reduction in workload or compensation for the extra hours you are working. You can adapt the details to your own circumstances.

THE PROBLEM

Crunch periods are to be expected on any game, but yours has gone on continuously for several months, with no end in sight. The extra hours you are working are starting to affect your personal life.

THE INFORMATION YOU NEED TO COLLECT

:: A detailed log of the hours you have worked each day during the crunch period.
:: The number of tasks you are assigned each week, and how many of them are delivered early, on time, or late.
:: Written documentation showing how long it takes to get approval or feedback on a concept.

YOUR ARGUMENT

"For the past three months, I have been given up to ten assignments in a week, and have been coming to work at 6 a.m. and leaving at 10 p.m. to meet those deadlines. On Saturdays, too. You are paying me for eight hours of labor each day, but my workload is twice that. The strain of meeting these deadlines is affecting my health and personal life, and I can no longer work under these conditions. I am asking that you either lighten my workload or give me an extended vacation to recuperate."

It can be daunting to search through your records to find documentation of your excellence. Instead I recommend you keep a running tab as you go. Here are two simple things you can do:
When someone praises you in an email, label it so you can reference it later. Every time you save the day at work, document it on your cell phone. Include the date, time, and describe the incident. Thursday, May, XXXX, 11pm. Stayed late to complete last minute task for X producer so that art is completed in time for Friday morning meeting with publisher. (it's important to keep track of names as well)

IF YOU ARE UNHAPPY WITH A COWORKER

Problems with coworkers can range from personality clashes with other artists to difficulties with management. The latter are particularly frustrating since, in addition to creating unnecessary stress, they can reduce the chances of your work being included in the game. Below, we'll explore another fictitious case study illustrating the issue, and the way in which you could resolve it.

THE PROBLEM

Your associate producer likes to play art director and will force you to explore their bad ideas. To make things worse, he has a habit of micromanaging your tasks. Meanwhile, there are other, more important assignments that you are neglecting. As a result, you are missing your deadlines, and the stupid side projects you get from the associate producer go nowhere.

THE INFORMATION YOU NEED TO COLLECT

:: Written documentation illustrating your associate producer's incompetence, and how it affects your ability to deliver usable art: for example, briefs that are vague, incomplete, or contradictory.
:: A detailed log of the number of revisions you are asked to do on a task, and why.
:: A figure for the percentage of tasks you receive that actually get used in the game.

YOUR ARGUMENT

"My associate producer's ignorance is a constant roadblock to my daily work flow, and is directly responsible for content not making it into the game. He constantly supplies me with incomplete details, loose napkin sketches and vague instructions for each task, which ultimately results in excessive revisions and wasted time. For these reasons I would like to have him removed from the decision-making process, or to be placed under a different manager."

IF YOU ARE UNHAPPY WITH THE PROJECT

Systemic problems at a studio are usually the hardest to resolve, because they involve so many people. For that reason, the solution may not be to try to tackle the issue alone, but to rally the support of your colleagues. Again, we will set out a case study illustrating a typical situation, and how you might go about resolving it. In this case, the final section isn't an argument you could use, but a general strategy.

THE PROBLEM

The current state of the game is so poor that it has lowered morale within the studio. None of the artists feel good about the project and believe that the game is on a fast track to failure. Bad decisions are made repeatedly because the lessons learned from past mistakes are not being implemented.

THE INFORMATION YOU NEED TO COLLECT

Nothing. Even if you could document everything that is going wrong on the project single-handed, individual efforts tend to backfire in these cases.

YOUR STRATEGY

If your concerns are shared by your coworkers, and you can convince them to take a stand, voice their complaints alongside yours. If many people say the same thing, it becomes much harder to ignore. Raise your concerns about the quality of the game, and your belief that the only solution is to reboot the title or to bring in new management. It's a long shot, but if the entire team stands united in its claims, and presents its case to the highest authority, real change can happen in a studio.

Don't automatically assume the worst. Every project that I have worked on has gone through turbulent waters. In most cases, the pattern is the same: people leave, new people are hired, the renewal of talent reinvigorates the studio, and the project moves forward.

THREATENING TO QUIT

If you have exhausted all of the normal channels of diplomacy and still not seen any meaningful efforts to resolve a problem, your only other option may be to threaten to quit. This is a difficult and delicate situation. With the right approach, and realistic expectations, you may be able to use the extra leverage that the threat of leaving grants you to resolve your concerns. Approach things in the wrong way, however, and you will really have to walk away.

In such situations, the information you need to collect to support your case and the way in which you frame your argument are the same as in the previous examples: you are simply raising the stakes, letting the management know how serious the issue is to you.

Threatening to quit is always a gamble—be sure that you are fully prepared to walk away from the job before you do so. Also, since you can only use the threat once before it loses its power, be certain that the cause you are fighting for is a worthy one.

NEGOTIATION TIPS

:: Never start negotiations with entitled statements like: "You owe me ..."
:: Don't get emotional—keep a level head.
:: Always have your facts straight.
:: Have documented cases where you were crucial to a project.
:: Know how your own work benefits the team.
:: Make a business case for the changes you want, not a personal one.
:: Use your seniority to your advantage.
:: Never give ultimatums ("if you don't do X, then Y will happen")—they rarely work.

PROVE YOUR WORTH FIRST

One trick I've learned that will improve your chances of your voice being heard is to make sure that managers understand who you are, and your value to the project. This means you have to take the initiative and get involved in the day-to-day activities of the studio. Attend meetings, come up with solutions, and work with as many different people as you can.

I know it feels counterintuitive to invest yourself in a job in which things are going wrong, but making your contributions visible across as many departments as possible is the best way to gain support for your cause. When the higher-ups hear that you are threatening to quit, it can be the difference between, "Eliott who?" and, "Oh shoot, Eliott can't leave!"

THINGS TO DO BEFORE YOU QUIT

:: Review your portfolio: if it's out of date, focus on creating new personal work.

:: Cultivate contacts at other studios: you will need to sound them out for jobs.

:: Save money: ideally, you should build up enough savings to cover six months without work.

:: Keep your living expenses down: the less you spend, the further your savings will go while you look for a new job.

:: Avoid making major purchases right before the holidays: this is often when layoffs occur.

We all like to think that a project can't go on without us, but the truth is, it can. Changing companies is a time-consuming and career-influencing move—do not make it lightly.

DECIDING TO QUIT

Good problem-solvers naturally try to fix things. But some situations can't be fixed, and it's critical to acknowledge the personal and professional cost of continuing the relationship. If you believe that the culture of a studio is entrenched, and abusive, it's best to get out before it does irreparable damage to your personal relationships, health, and career.

This is a very, very hard lesson to learn: most people stay and continue to accumulate damage that can take years to unwind. By the time they leave, they're unlikely to be in the right frame of mind to interview for a new position. No employer wants to hire damaged goods, especially when there is an abundance of good candidates on the market.

The power of quitting is that you are taking control of the situation, taking your future into your own hands. Never quit in anger: always try to leave the studio on good, or at least respectable, terms. Learn from the past, but see the next opportunity as a fresh start.

IS THE GRASS REALLY GREENER ELSEWHERE?

Every company has its problems: some just manage them better than others. There are only a handful of studios that really nurture their artists while providing creative freedom on their projects, and they are notoriously hard to get into. As long as you're working for somebody else, there will almost always be times when you think you can make better choices than the management.

So before you decide to leave, assess how bad things really are. This can be hard to judge if you haven't worked at many other companies, so talking to colleagues in the industry can help. Choose your next studio wisely before leaving your current employer: it doesn't make sense to jump from one sinking ship to another.

The industry is crazily small, with two degrees of separation or fewer between most studios. So do your best regardless of the circumstances. If you leave on the best terms possible, your former colleagues will remember you and keep you in mind when positions become vacant in the future.

TIMING YOUR EXIT

The best time to get out from a toxic studio is before everyone else does. If a project is obviously failing—often referred to in the industry as a "sinking ship"—many other people will seek out new employment opportunities. However, because there are only a limited number of positions available at any given time, there is a high probability that you and your coworkers will be fighting over the same jobs. This is great for any studio looking to hire new talent, but it can be devastating for you.

Once word gets out that your studio is struggling, it can adversely affect your ability to negotiate a new job. If an employer knows that you are desperate to leave, it may take advantage of the fact to offer you a lower salary. Worse still, due to the overabundance of talent in the market, if you are not one of the best artists in your field, you may be out of a job altogether.

TRAVEL LIGHT

Be warned: those collectible figures, art books, boxes of comics, video game consoles—and whatever else you like to collect—become a major pain to move every time you switch jobs. If you have furniture or other bulky items in your possession, moving becomes even more of a headache.

A concept artist colleague of mine once told me that the biggest pieces of furniture he owned were a mattress and his computer. At the time, I thought this was a bit extreme, but after years of collecting junk, then going through the repeated hassle of moving, I realize that he was something of a genius. He understood that no job is guaranteed, and that the nature of this industry is to move where the work is, so he lived his life that way—able to pack up and move as he pleased.

A Personal Story:

An industry buddy of mine had a child and quickly realized that good, bad, or ugly, he was stuck at his current studio because he needed the health-care benefits. This couldn't have come at a worse time, since the project he was working on was in turmoil and the studio's future was uncertain.

Despite wanting to speak out to management about the status of the game, he felt that he couldn't rock the boat for fear of losing his job. Instead, he would complain to his buddies. I'll never forget how miserable he was: constantly stressed, and feeling trapped and angry at the world. This must have gone on for months. Watching him taught me to plan my own life better.

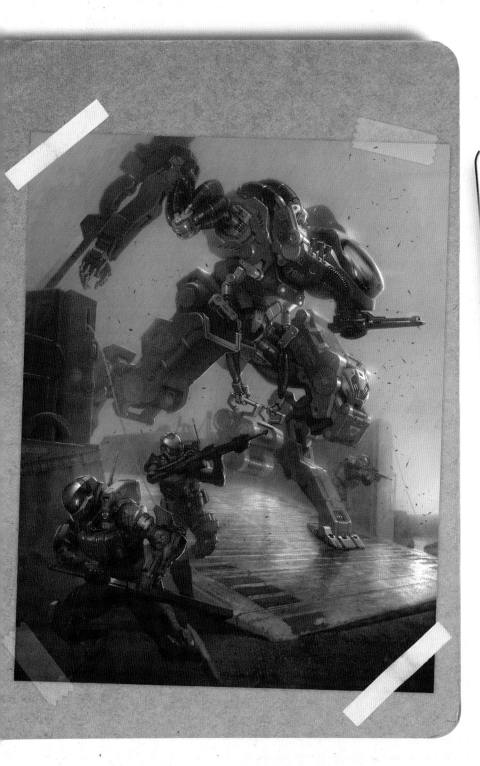

- CHAPTER 09 -

SUSTAINING YOUR CAREER

DECIDING WHERE TO FOCUS YOUR ENERGY

Over the course of your career, you're only going to be able to produce a fixed amount of work, take part in a limited number of projects, and work at a handful of studios. You have to pick and choose your battles wisely. In most cases, this means adopting one of two strategies.

Some artists define themselves through the clients they have worked for, and the projects they have worked on; others see the jobs they take on as a means to finance their own personal projects. Let's look at what each approach means for your choice of jobs.

TO FOCUS YOUR ENERGY ON WORK

:: Target high-profile projects, or titles that excite you.
:: Go after the clients or studios you really want to work for.
:: Carve out your niche and own it.
:: Make sure you are getting paid your worth.
:: Align yourself with other high-status artists.

TO FOCUS YOUR ENERGY ON PERSONAL PROJECTS

:: Don't take jobs that demand long hours and unflinching loyalty. They will suck up all of your time.
:: Think about becoming a freelance concept artist, or at least work for companies who will allow you to develop outside projects.
:: Constantly challenge yourself to learn and grow at home.
:: Give yourself freedom to explore your own ideas and develop your own projects.
:: Align yourself with like-minded individuals, and collaborate with them.

The two approaches aren't mutually exclusive, but to do both takes an enormous amount of energy. Trust me, working a job that keeps you at the office from 10 a.m. to 8 p.m. every day doesn't leave much room for a personal life.

It's good to keep working on your portfolio, even if you're in a job you love. Sadly, bad things can and do happen to good studios. If you carry on creating personal work, you don't have to scramble as much if you need to find a new position in a hurry. And keep up with industry friends: they can be lifesavers.

HOW TO STAY COMPETITIVE

In a fast-moving industry like concept art, you have to adapt to change. This means learning new skills and taking on new challenges, while striving to preserve the qualities that make you unique as an artist. The following tips should help you to stay competitive.

ALWAYS HAVE SOMETHING NEW TO SHOW

The nature of concept art means that most of what you work on can never be shown to the public. The images you can display publicly may not accurately reflect your work on a project, or may be from games that are years old. If you have the bad luck to work on a project that gets canceled, your work may stay in limbo. Stay relevant by creating your own personal work alongside your professional work.

KEEP EXPERIMENTING AT HOME

The work you do professionally is not always a reflection of your own interests. Don't rely solely on your job for your own growth as an artist: I am a firm believer that your personal voice is developed in your own time. The work that you do at home allows you to be creative without the restrictions imposed by deadlines, guidelines, and peer expectation, and enables you to explore happy accidents.

STAY IN COMPETITION WITH YOURSELF

No teacher in the world can make you a better artist if you don't have the drive to do so on your own. If you get lazy and don't constantly push yourself, you may be jeopardizing your long-term career opportunities.

DON'T COPY YOUR PEERS

While it is healthy to compare your work to that of other artists to assess whether your skills are still competitive, never become a slave to current trends. Remember the things that make your work unique and stick with them.

KEEP LEARNING NEW TOOLS

Technology is evolving rapidly, and you don't want to get left behind. Don't be afraid to learn new tools, particularly if they enable to work more quickly, or achieve a better result. But don't throw away everything you have already learned: the trick is to adapt the latest tools into a workflow that works for you.

MAINTAINING WORK-LIFE BALANCE

Even once you've landed your dream job, there are still pitfalls to avoid. While it's natural to want to commit to work you enjoy, it's important to establish clear boundaries between your job and your personal life. Here are two things you need to do to preserve a healthy work-life balance.

DON'T INVEST TOO MUCH OF YOURSELF

While you should be passionate about your job, it's dangerously easy to become overinvested in your own ideas. Even if you think they are brilliant, they may not be shared by the rest of the team. Becoming emotionally entangled with an idea, spending personal time to bring it to fruition, then having it rejected by the studio is the fastest way to get burned-out. It only takes a few such cases before you grow numb and stop caring. This can ruin your perception of the job and your enjoyment of the work—one of the main reason that people change careers.

DON'T LOSE YOURSELF TO CRUNCHES

If you've "crunched" (worked long hours to get a project out of the door) for extended periods of time, it's easy to lose objectivity, and you may wind up putting your foot in your mouth. Avoid grumbling or gossiping: it's better to do your best work and then pack it in for the day.

Crunches can be a management issue. If you're working late consistently, there's a case to be made for hiring another staff member. If the budget doesn't allow for it, the scope of the project may be too great. And if you're working late simply to appease a disagreeable boss, it may be time to get your portfolio together.

It is worth mentioning that legally, studios cannot demand that you crunch, because they are only paying you for an eight-hour workday. The only way they can require you to work longer hours is to pay you overtime. Instead, an employer will often try to incentivize you by offering bonuses for working late. Worse, they may say things like, "The company's future depends on this game's success," insinuating that if you don't work hard, the studio will close. No pressure, right?

Working extra hours puts unwanted stress on your social life, your relationships, and your family. Do it, but don't kill yourself. I've seen guys at my studio work 20-hour days for two weeks straight—and that seems crazy to me. I'm all for hard work, but there are limits.

Remember: this is not your baby. It is not your mission statement to the world. It's a job. While you should always do your best, establish boundaries. If you have to crunch, make an agreement with the important people in your life to make time for them. I have found that setting aside a day or night a week is a good way to establish some sort of normalcy during the long crunch months.

Even if you are already working in the industry, it is not too late to reevaluate where you stand in your career and where you want to go, then take the steps necessary to get there.

SOME ADVICE FROM ME TO YOU

To conclude this chapter, here is some personal advice. Some of these tips are things I knew going into the industry, but some of them are things I wish I had been told in advance. So now I'm telling you, so that you don't have to learn the hard way.

YOUR ART IS ONLY AS GOOD AS YOUR AMBITIONS

The more effort you put into developing your craft, the more options you will have during your career. Commit wholly to this endeavor, and always try your hardest to achieve your goals. Don't let anyone tell you what you can or can't do.

YOU NEED A LONG-TERM PLAN

I am a believer in having a five-year plan. Keeping my long-term goals in mind allows me to chart a course around any big events, and to correct that course when necessary. When planning, keep in mind that the best time to take risks in your career is when you are young, and don't have many responsibilities or distractions.

STAND UP FOR YOURSELF AT WORK

Unless you establish limits to what your boss can ask of you, it will be difficult to maintain your personal life. If a task seems unfair or a deadline seems impossible, stand your ground and propose a better solution. Don't let your employer walk all over you.

BE PROFESSIONAL WITH EVERYONE

People's impressions of you are very important. Their perception of you as a person, and of your abilities as a professional, will travel with them from job to job. If they enjoyed working with you, they are more likely to think of you when their new studio needs concept artists. This applies to everyone: even video game testers can later become producers, with the power to hire and fire you.

YOU'RE ALWAYS COMPETING WITH STUDENTS

Recognize that there is always new, young talent that is hungry for the spotlight. With every passing year, students gain more exposure to the industry. They have access to the same tools and training materials as you. And being students, they will work for less money. Don't rest on your laurels.

DON'T RELY SOLELY ON YOUR JOB FOR INCOME

Try to establish other money-making ventures to supplement your income, even if they are small. Think about putting out an "art of" book, or lecturing at a university, in a paid workshop, or for an online training company. Your side projects don't even have to be art-related. That way, if the bottom falls out from your job, you have something to fall back on while you scramble to your next.

LIVE BELOW YOUR MEANS

Regardless of your salary, make sure you aren't spending as much as you make. Don't go into debt to buy a new car: you need to save money in case of an emergency, like studio-wide layoffs. As well as giving you the financial security to survive during turbulent periods in your career, a decent-sized nest egg will enable you to take more creative risks.

As a bare minimum, your nest egg should be able to keep you afloat for three months: to cover all of your basic expenses, like rent, student loans, groceries, and your cell phone bill. If you can save six months worth of expenses, you can begin to breathe a sigh of relief, and if you maintain a years worth, you're golden! Start saving for it as soon as you get your first paycheck. The more money you can put away, the better.

– CHAPTER 10 –

RECOMMENDED RESOURCES

JOB-HUNTING RESOURCES

A selection of websites that may be useful to you when looking for a new job. This is by no means an exhaustive list, but it includes the most popular options, sites that I have used myself, and ones that have been recommended to me by my peers. For more in depth list of resources, head over to http://bigbadworldofconceptart.com.

JOB BOARDS, FORUMS, AND LISTINGS
Websites that include listings of current full- and part-time jobs for the video game and entertainment industries.

Artstation	https://www.artstation.com/jobs
Gamasutra	http://www.gamasutra.com/jobs
Games Jobs Direct	http://www.gamesjobsdirect.com
GameJobHunter	http://www.gamejobhunter.com/
Polycount	http://polycount.com/categories/work-opportunities

JOB SEARCH ENGINES (AGGREGATORS)
Websites that will compile a list of current jobs matching your skills and location. The first one is specific to the video game and entertainment industries; the others are non-specialist.

CreativeHeads.net	http://www.creativeheads.net
Glassdoor	http://www.glassdoor.com
Indeed	http://www.indeed.com
SimplyHired	http://www.simplyhired.com

RECRUITING AGENCIES
Some of the larger recruitment firms that specialize in the video game industry. Do your research before signing up for one.

Adventure Recruitment	http://www.adventurerecruitment.com/
Game Recruiter	http://www.gamerecruiter.com/
Amiqus	http://www.amiqus.com/

Disclaimer : Although they have approached me, I have never used a recruiter or their services before.

SALARY RESEARCH

A selection of resources to help you determine the current market rate for your services. Useful for finding background information before attending a job interview or performance review, or calculating your base salary needs.

SALARY SURVEYS

Industry-wide salary surveys covering a range of disciplines and levels of experience.

Develop	http://bit.ly/developsalarysurvey
Gamasutra	http://bit.ly/gamasutrasalarysurvey
Payscale	http://www.payscale.com/
Salary.com	http://salary.com

COST-OF-LIVING CALCULATORS

Tools to help you determine how far your paycheck will stretch from city to city.

CNN Money	http://money.cnn.com/calculator/pf/cost-of-living/
PayScale	http://www.payscale.com/cost-of-living-calculator
Salary.com	http://swz.salary.com/costoflivingwizard/layoutscripts/coll_start.aspx

WEBSITE BUILDERS

Artstation	https://www.artstation.com/pro
Squarespace	https://www.squarespace.com/
Weebly	https://www.weebly.com/
Wix	http://www.wix.com/

SELF-PROMOTIONAL RESOURCES

A selection of resources to help you market your self effectively, including online printing services for postcards and other merchandise, industry events at which to network, and game art contests you can enter to raise your public profile.

ON-DEMAND PRINT SERVICES
Services for printing your images onto postcards or other "leave behind" material. Affordable, with quick turarnound times.

Clubflyers.com	http://www.clubflyers.com
Moo	https://www.moo.com
PrintRunner	http://www.printrunner.com
UPrinting.com	http://www.uprinting.com
Vistaprint	http://www.vistaprint.com

GAMES CONVENTIONS AND EXPOS
The best conventions at which to meet recruiters for the major video game studios.

Electronic Entertainment Expo (E3)	http://www.e3expo.com
Game Developers Conference (GDC)	http://www.gdconf.com
Penny Arcade Expo (PAX)	http://www.paxsite.com
San Diego Comic-Con	http://www.comic-con.org

GAME ART COMPETITIONS
Being selected for entry into these international contests will raise your profile in the industry.

ArtStation	https://www.artstation.com/contests
Into the Pixel	http://www.intothepixel.com
Spectrum	http://www.spectrumfantasticart.com/

OTHER HELPFUL LINKS

Other resources of note, including the main online gallery services specializing in professional video game and entertainment art, industry news sites, and a selection of blogs and podcasts for you to follow.

PROFESSIONAL ONLINE GALLERIES AND FORUMS

3DTotal	http://www.3dtotal.com/
ArtStation	https://www.artstation.com
CG Society	http://www.cgsociety.org/
Concept Art World	www.conceptartworld.com
GameArtisans.org	http://www.gameartisans.org
ZBrushCentral	http://www.zbrushcentral.com

VIDEO GAME INDUSTRY NEWS

Gamasutra	http://www.Gamasutra.com
GamesIndustry.biz	http://www.GamesIndustry.biz
GameCareerGuide.com	http://www.gamecareerguide.com
Kotaku	http://www.kotaku.com

VIDEO GAME CONCEPT ART GALLERIES

Creative Uncut	http://www.creativeuncut.com/game-art-galleries.html

VIDEO GAME STUDIO MAPS

Gamedevmap	http://www.gamedevmap.com

BLOGS AND PODCASTS

Hans Bacher	http://one1more2time3.wordpress.com
James Gurney	http://gurneyjourney.blogspot.com
Muddy Colors	http://muddycolors.blogspot.com/
Chris Oately	http://oatleyacademy.com
Parka Blogs (art book reviews)	http://parkablogs.com/
Temple of the Seven Golden Camels	http://sevencamels.blogspot.com

EVERYTHING YOU EVER WANTED TO KNOW ABOUT CONCEPT ART

VISIT: **BIGBADWORLDOFCONCEPTART.COM**

■GUIDANCE ■CAREER ADVICE ■TRAINING MATERIALS ■EDUCATIONAL RESOURCES

AN INSIDER'S GUIDE FOR STUDENTS—OUT NOW

Features practical advice for students to achieve noticeable improvements in work ethic and career preparation.

- How to choose the school that's right for you
- How to get the most out of your education
- How to develop your portfolio and much more ...

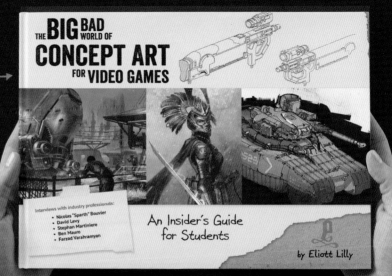

THE **BIG BAD** WORLD OF
CONCEPT ART
FOR **VIDEO GAMES**

Interviews with industry professionals:
- Nicolas "Sparth" Bouvier
- David Levy
- Stephan Martiniere
- Ben Mauro
- Farzad Varahramyan

An Insider's Guide for Students

by Eliott Lilly

 Find us on **Facebook**

CONTACT ME
me@eliottlillyart.com
Portfolio: **http://www.eliottlillyart.com**
Blog: http://bigbadworldofconceptart.com/

I couldn't possibly cover everything there is to know about careers within these pages, but I really hope that I've been able to shed some light on how to get going in the right direction, and what to do when you get there. At this point, if you are a little intimidated or scared about this industry, that's OK.

If you have worked, or are working at the "wrong studio," keep in mind that it's not the end of the world for your career—just try to get it right next time. Now that you are armed with this information, if you apply it to your own situation, you will succeed eventually. Keep working hard and push yourself to improve, but remember to relax, take your time, and enjoy the ride.

If you found this book helpful, I would ask that you do a few things:

1. Tell your fellow aspiring artists, friends, and colleagues about this book, and encourage them to purchase their own copies.
2. Post reviews on social media outlets and leave testimonial comments on my storefront to let other people know that reading the book is time well spent.
3. Most importantly, please subscribe to http://bigbadworldofconceptart.com. Doing so not only shows your support for me and my efforts, but also serves as a direct line of communication between us.

If you have a question about something I haven't covered in the book, send it to me at the e-mail address above, and if I have time, I'll do my best to answer it. (No promises, though!)

Acknowledgements

Another round of thanks goes to those who helped me gather, organize, and arrange my thoughts in this second book—and for taking the time to offer honest feedback. I am truly fortunate to have such supportive friends and family.

Special thanks to:
Chris Oatley Brian Hsia
Tim Coman Tony Huynh
Phu Giang Alex Bostic

Kim Deng (My wife) for helping me focus my thoughts in this book and for loving me unconditionally despite my ambitious endeavors and work-aholic nature.
Edna Johnson (my mom), for all of her support over the years, and for encouraging me to follow my dreams. Charles Lilly (my dad), who constantly pushed me to be the best. I didn't understand it then, but I understand it now.

And to all of the readers of the blog who submitted questions that helped shape this book: thank you.

Always be in competition with yourself.
Eliott

OTHER TITLES FROM DESIGN STUDIO PRESS

THE SKILLFUL HUNTSMAN
Paperback ISBN 978-0-97266-764-7

HOW TO DRAW
Paperback ISBN 978-1-93349-273-5
Hardcover ISBN 978-1-93349-275-9

HOW TO RENDER
Paperback ISBN 978-1-93349-296-4
Hardcover ISBN 978-1-93349-283-4

THE SILVER WAY
Paperback ISBN 978-1-62465-034-5

CREATIVE STRATEGIES
Paperback ISBN 978-1-62465-026-0

STRUCTURA
Paperback ISBN 978-1-93349-225-4
Hardcover ISBN 978-1-93349-226-1

STRUCTURA 2
Paperback ISBN 978-1-93349-265-0
Hardcover ISBN 978-1-93349-266-7

STRUCTURA 3
Paperback ISBN 978-1-62465-012-3
Hardcover ISBN 978-1-62465-011-6

ART OF PAPERBLUE
Paperback ISBN 978-1-62465-014-7

To order additional copies of this book and to view other books we offer, please visit:
www.designstudiopress.com

For volume purchases and resale inquiries, please email:
info@designstudiopress.com

To be notified of new releases, special discounts and events, please sign up for the mailing list on our website, join our Facebook fan page, or follow us on Twitter:

 facebook.com/designstudiopress
 twitter.com/DStudioPress